Leonardo da Vinci

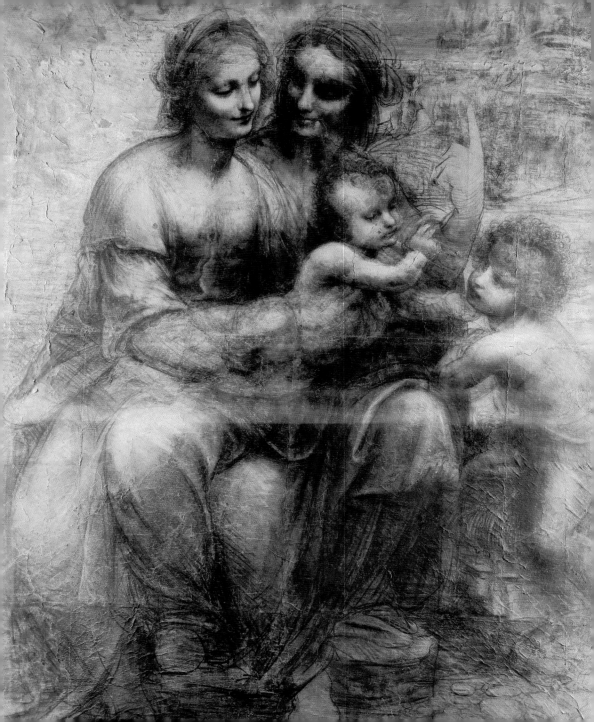

Leonardo da Vinci

Life and Work

Elke Linda Buchholz

KÖNEMANN

Youth in Florence
Page 6

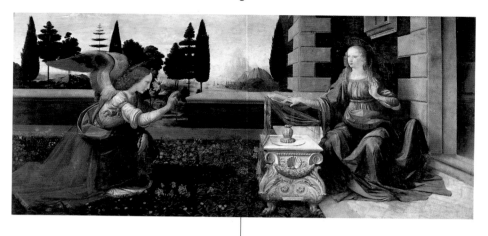

| 1452 | 1470 |
| 1490 | 1495 |

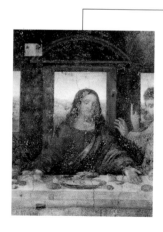

A Master of Painting
Page 38

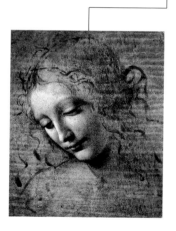

Restless Years
Page 52

Independence
Page 16

Uomo Universale
Page 26

Return to Milan
Page 66

Last Years
Page 78

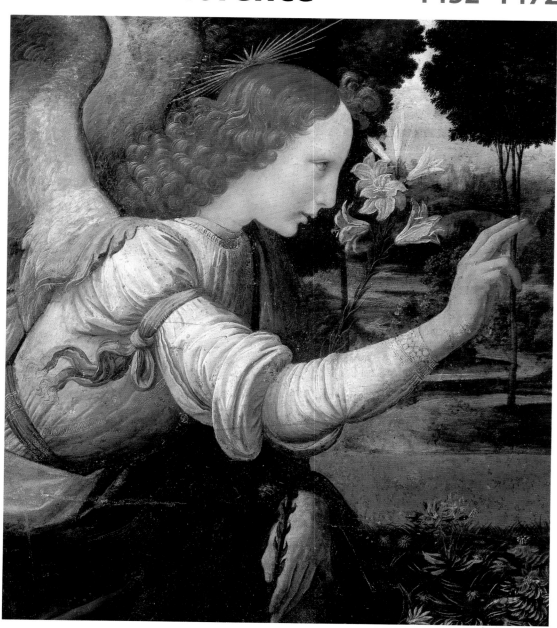

Leonardo was born in Vinci near Florence, and spent the first years of his life in this small country town. The boy was the illegitimate child of a farm girl and a notary who married another woman soon after. It is not known when he first began to draw or paint, but Leonardo's artistic talent must have been apparent at an early age. His father took the teenager with him when he moved to Florence, where the young da Vinci became an apprentice to the sculptor and painter Andrea del Verrocchio. Florence at that time was Italy's capital of art, a lively city open to all that was new, and Leonardo became familiar with the art of the early Renaissance in the streets and churches of the city as well as in his teacher's workshop. His early works show that, even before he had completed his apprenticeship, his paintings were already excelling those of his master.

Mohammed II conquers Constantinople

1453 Mohammed II, Sultan of the Ottoman Turks, conquers Constantinople with his army and destroys the Byzantine Empire.

1455 Beginning of the Wars of the Roses. The Gutenberg Bible, the first large printed book, is published.

1469 Lorenzo de' Medici ("the Magnificent") comes to power in Florence.

1471 The painter Albrecht Dürer is born.

David by Andrea del Verrocchio

1452 Leonardo is born on April 15 in Vinci near Florence, the illegitimate child of a notary, Ser Piero, and a farm girl, Catarina. In the same year, his father marries a young Florentine woman. At first, Leonardo is cared for by his mother who also marries shortly thereafter.

1457 Leonardo lives with his paternal grandparents in Vinci.

1467 His father marries a second time after the death of his wife.

1468 Ser Piero takes offices in Florence.

1469 Around this time Leonardo moves to Florence with his father. He begins his apprenticeship in the workshop of the painter and sculptor Andrea del Verrocchio.

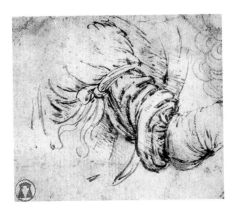

Opposite:
The Annunciation, ca. 1470–1473 (detail)
Oil and tempera on wood
Florence, Galleria degli Uffizi

Right:
Sleeve study for the Annunciation, ca. 1470–1473
Red chalk on paper, 8.5 x 9.5 cm
Oxford, Christ Church

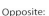

From Vinci to Florence

The name Leonardo da Vinci means no more than "Leonardo from Vinci." It was customary in Italy for a person's surname to be connected to his ancestry, his place of birth or his profession. The story of Leonardo's life, right from birth, has been shaped by speculation: a carefully restored farmhouse in Anchiano close to Vinci is said to be the birthplace of Leonardo, but this has not been proved. Very little is known about Leonardo's childhood and youth; the earliest descriptions of his life from the sixteenth century were already a mixture of legend and reality.

The tax records of the time provide a few clues from which the first few years of his life can be reconstructed. A note written by his grandfather in the family album states: "1452. On Saturday, April 15 at three in the

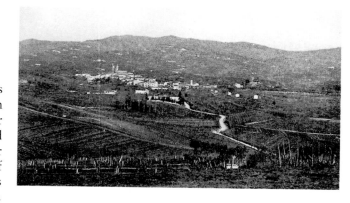

morning, one of my grandsons, a son of my son, Piero, was born. He bears the name Leonardo. The priest Piero di Bartolomeo from Vinci baptized him…" We know only the first name of his mother – Catarina or Caterina; she was 22 years old when Leonardo was born. Marriage to the father of the child, the notary Ser Piero, was clearly never considered. He came from a family of notaries who had always had close connections to Florence. In the same year as Leonardo was born, his father married a young woman from a

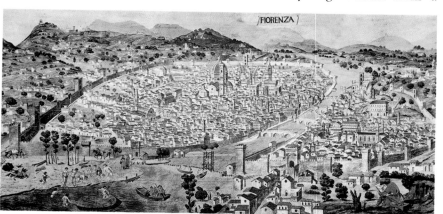

respected Florentine family. Leonardo would have stayed with his mother until the age of one or two since breast milk was the only food available to infants at the time. An illegitimate birth was no great cause for shame in Italy in the fifteenth century – in contrast with later ages – but it generally meant that professional careers in law or medicine were denied the child. Leonardo later stayed with his grandparents and grew up on their farm in direct contact with nature. It may be that his lifelong passion for the natural world had its roots in these childhood experiences. His school education was limited to reading, writing, and arithmetic, but a special gift for drawing almost certainly was revealed from an early age. When it was time to begin thinking about an apprenticeship for the boy, his father decided to take Leonardo with him to Florence. He had rented offices for his dealings as a notary in the center of town, in what is today the Via Gondi, behind the Palazzo Vecchio, the Town Hall. It may be that he had business contacts with the distinguished painter and sculptor Andrea del Verrocchio, to whom he showed some of his son's drawings. Verrochio was thereupon more than ready to take Leonardo into his workshop.

Landscape drawing, dated 5 August 1473
Pen and ink drawing
19 x 28.5 cm
Florence, Gabinetto dei Disegni e delle Stampe

Leonardo's earliest landscape drawing conveys an impression of the landscape in which he grew up. The drawing does not depict any particular landscape; it is rather a combination of the real and the invented.

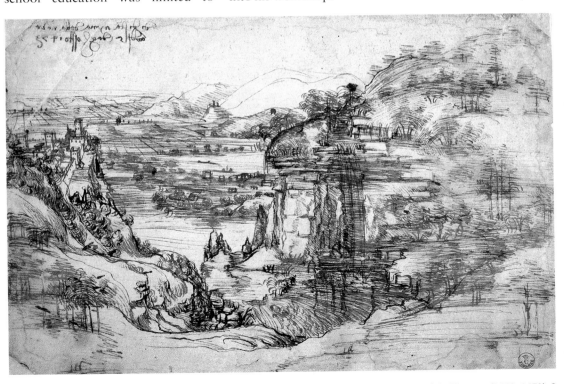

In Verrocchio's Studio

The workshop of Andrea del Verrocchio was one of the most important centers of artistic learning in Florence in the late fifteenth century. Born around 1435, Verrocchio was originally a goldsmith before making a name for himself as a painter and sculptor. He must have been an enormously versatile and multi-faceted man who passed on his exceptional technical ability to his pupils. He was a master of bronze casting, sculpted in clay and marble, but he also painted and

The Madonna with the Carnation, 1472–1478, oil on wood, 62 x 74.5 cm Munich, Bayerische Staatsgemälde-sammlung, Alte Pinakothek

This picture is considered one of Leonardo's earliest paintings; it shows strong similarities with other work from Verrocchio's studio. The wrinkled surface of the paint indicates that Leonardo was experimenting with bonding agents with a high oil content.

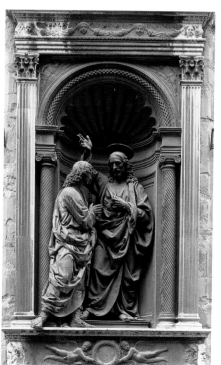

Andrea del Verrocchio
Christ and Doubting Thomas
1467–1483
Bronze
Height 230 cm
Florence,
Orsanmichele

The apostle Thomas touches the wound in Christ's side to convince himself of the Resurrection. Verrocchio created this bronze group when Leonardo was still an apprentice in his studio. The uninhibited movement of the figure around its own axis – as seen here in the figure of St. Thomas – is characteristic of Verrocchio.

drew extensively. The gigantic sphere of gilded bronze for the dome of Florence Cathedral – a brilliant technical achievement – was made in his workshop.

We do not know exactly when Leonardo first entered the *bottega*, the workshop, but he was living and working with Verrocchio by 1469 at the latest. At the beginning of his apprenticeship he learned how to make paint, how to prepare surfaces for painting with plaster, and how to model in wax and clay. Verrocchio's studio welcomed experimentation; in addition to painting in tempera, a practice common in Italy which used an emulsion with an egg base, Leonardo would have come into contact with the technique of oil painting. An innovation at the time, oils had been introduced to Italy from Flemish painting. The *Dreyfus*

Andrea del Verrocchio and Leonardo da Vinci
Baptism of Christ
1473–1475
Oil and tempera on wood, 177 x 151 cm
Florence, Galleria degli Uffizi

This painting is a good example of the cooperation between different artists in Verrocchio's workshop. Close examination reveals how the individual parts of the picture have been differently treated. Verrocchio himself began the picture, and Leonardo later added the kneeling angel at the outer left as well as painting over the figure of the unclothed Christ with a glaze of oils. Compared with the figure of the Baptist, Christ's body has been vigorously yet delicately modeled. Even the background landscape is a characteristic creation of Leonardo's. Leonardo's apprenticeship had probably already ended by this time. Even Sandro Botticelli, who worked for a period in Verrocchio's studio, may have been involved in the production of this picture: the right-hand angel of the pair suggests his style.

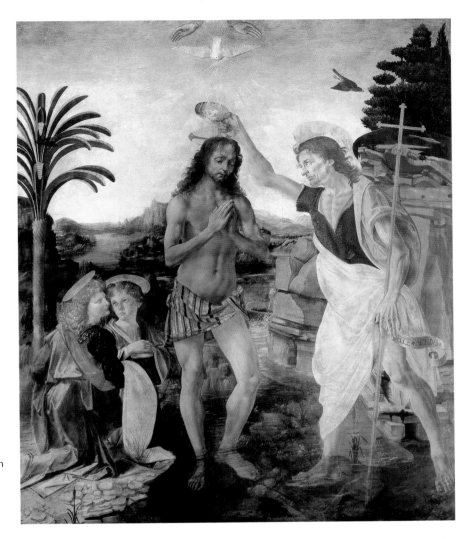

Madonna was one of the earliest oil paintings in Florence. It appears the members of Verrocchio's studio worked closely together and occasionally exchanged designs or drawings. Often a commission was executed by several artists working together, making it difficult today to determine the authorship of works from Verrocchio's circle. Even when Leonardo's apprenticeship officially came to an end in 1472, the 20-year-old artist remained with his teacher on independent terms. By this time Leonardo was at least the equal of Verrocchio – if not his superior.

The Early Renaissance in Florence

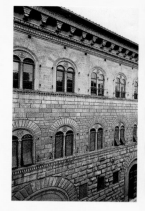

In the fifteenth century Florence was one of the most prosperous and progressive cities in Italy. Well-traveled merchants and powerful bankers promoted art and crafts, especially Cosimo de'Medici, one of the wealthiest men in the city, and the real source of power in Florence. In the course of 150 years, the Medici rose from an international banking house to dukedom, finally ruling a state as large as Tuscany. Florence, with its imposing buildings, was already an important city in the Middle Ages, but it underwent great changes in the Quattrocento, as Italians call the fifteenth century. Broad streets were built in previously densely built quarters. In order to construct a family palace like the Palazzo Medici-Riccardi, dozens of old medieval houses were demolished. These external changes were above all an expression of the developing self-consciousness of the middle classes, and of a new way of thinking. Art and culture were created in the unique atmosphere of a new beginning which even to contemporaries seemed like a "re-birth". The architect Leon Battista Alberti, one of the most famous art theorists of his age, coined the term *rinascitá* which in its French translation – Renaissance – came to be applied to the entire epoch. The term was intended to mean a cultural and spiritual renewal along the lines of classical antiquity. The beauty and size of antique architecture became the measure of the new art, and artists traveled to Rome in order to study buildings like the Coliseum or the city's triumphal arches. Writers and philosophers gathered at the court of the Medici to study, translate and debate the works of Classical authors such as Plato, Aristotle or Vitruvius.

Palazzo Medici-Riccardi in Florence, built by Michelozzo di Bartolomeo ca. 1444.
Photo of the facade.

In the Middle Ages Man was seen as but one element in a divinely ordained world; all earthly ambition was directed toward redemption in the afterlife. Gradually, Man himself came to occupy center stage in human thought. This increased interest in mankind, and its environment was reflected in the art of the early Renaissance.

The beauty of the naked human body became one of the favorite subjects for art. Artists such as Antonio del Pollaiuolo were not only guided by Classical art, they also studied the human anatomy of real models. With their newly gained self-confidence, artists no longer considered themselves mere tradesmen but built their art on "scientific" foundations: the study of the human model,

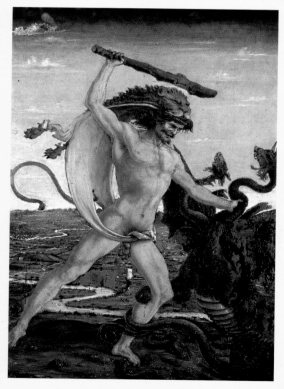

Antonio del Pollaiuolo
Hercules and the Hydra,
after 1460
Oil on canvas
16 x 10.5 cm
Florence, Galleria degli Uffizi

In our present century so many have stood out in this radiant and noble art, that every other age appears wretched by comparison!

Giovanni Santi, painter and poet, the father of Raphael Santi (ca. 1440–1494)

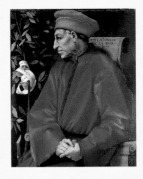

proportion, geometry and perspective (page 24). On the other hand, artists insisted more strongly than ever on developing an individual, inimitable style. As well as traditional Christian themes, Classical literature and mythology now began to make an appearance in art. In Botticelli's painting *La Primavera* (Spring), Venus, the goddess of love, invites the viewer into the dreamlike space of her garden where Apollo, the Three Graces, and Flora, the goddess of flowers, have gathered. The precise meaning of this poetic image is still debated today, but its delicacy and freshness is characteristic of early Renaissance art.

Sandro Botticelli
La Primavera, 1477–1478
Tempera on wood
203 x 314 cm
Florence, Galleria degli Uffizi

Above:
Jacopo Pontormo
Cosimo il Vecchio, ca. 1518
Oil on wood
86 x 65 cm
Florence, Galleria degli Uffizi

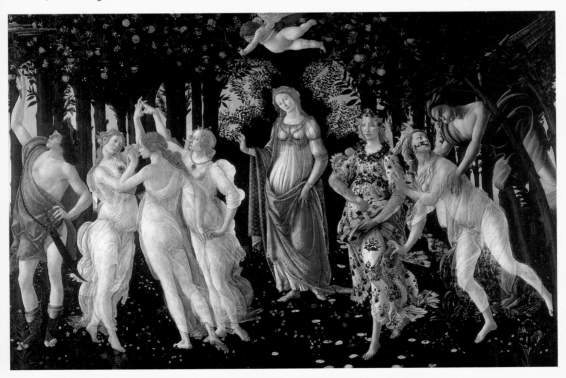

The First Great Painting

Like all his early works, Leonardo's painting of the Annunciation is not without controversy. There is no documentary evidence to support the claim that he worked on the picture, but the sophistication and execution of the detail seem to confirm it. It may have been made with the assistance of Domenico Ghirlandaio, who cooperated with Verrocchio's workshop for a time. The wings of the angel were changed at a later date by a less expert hand; unusually, Leonardo had painted them naturalistically as short bird's wings.

A masterly study of drapery is said to be related to the figure of the Virgin, even though the painted

Fra Filippo Lippi
The Annunciation,
ca. 1445
(detail)
Oil on wood
175.3 x 182 cm
Florence, San Lorenzo

The monk Fra Filippo Lippi, one of the best known painters of the Florentine Renaissance, made this *Annunciation* for a side altar in the church of San Lorenzo, where it is still to be found today. A particular feature of this work is the brilliantly recreated glass carafe in the foreground, which can be interpreted as a symbol of the Virgin's purity.

rendition is slightly different. The depiction of drapery was an important artistic exercise at the time. Even in the Middle Ages, artists had used the folds in drapery to convey either stress or serenity, nervous tension or concentration. During the Renaissance it became more usual to make the body seem ever more tangible beneath the clothing. In his biography of Leonardo from the sixteenth century, Giorgio Vasari wrote that the artist had made studies of cloth soaked in lime which he had draped over clay figures. A sketch for the sleeve of the angel (page 7) has also survived, and therefore it can be assumed that Leonardo prepared every aspect of the picture down to the last detail.

The Annunciation to the Virgin Mary was a popular theme in the painting of the fourteenth and fifteenth centuries. During the Renaissance, commissions on religious themes provided the greatest part of any artist's work, as they had always done; Leonardo therefore had recourse to a venerable artistic tradition. Almost certainly he was familiar with the work of his Florentine contemporaries such as the famous Annunciation picture by Filippo Lippi, a work typical of the early Renaissance. As in Lippi's painting, Leonardo's depiction of the biblical event does not seem at all abstract. Rather, it appears almost close enough to touch, an impression reinforced by the everyday objects and the carefully constructed architecture. The encounter between

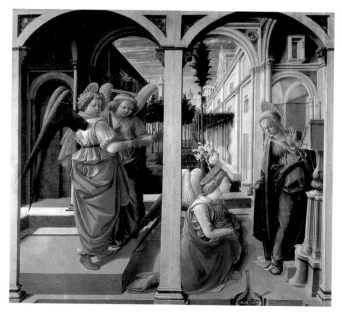

The Annunciation,
ca. 1470–1473
Oil and tempera on wood
98 × 217 cm
Florence, Galleria degli Uffizi

This early picture by Leonardo da Vinci is still firmly in the tradition of contemporary Florentine painting. The subtly executed drapery and the delicate landscape of the background (p. 76) are, however, typical of his style. As in so many of his paintings, he arranged the figures so that their faces are on a dark background in order to make their pale colors all the more conspicuous.

the Virgin and the angel Gabriel is told by gesture and body language. Lippi's angel waits reverently, while the Madonna draws back in shock. In Leonardo's picture, the kneeling angel raises his hand both in a gesture of greeting and to emphasize his words; the white lily in his left hand refers to Mary's virgin conception. The raised hands of the Virgin herself express welcome and surprise. The scene is played out in a walled garden, a *hortus conclusus*, an ancient symbol of Mary's virginity. She is sitting in front of a Renaissance-style house; on the lectern in front of her is a book, symbolizing her wisdom. Upon closer examination the picture reveals a few irregularities. The Virgin's right arm seems too long and its spatial relationship to the lectern is unclear; it is because of such flaws that this painting is thought to be one of Leonardo's very earliest works.

Drapery study for a seated figure,
ca. 1472–1475
Brush, gray tempera with white highlights
26.4 × 25.3 cm
Paris, Musée du Louvre

This carefully executed drapery study was most probably made in connection with *The Annunciation*. Such studies were part of an artist's education; they were executed in black and white as they were primarily concerned with the distribution of light and shade.

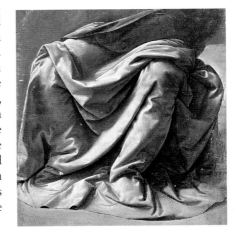

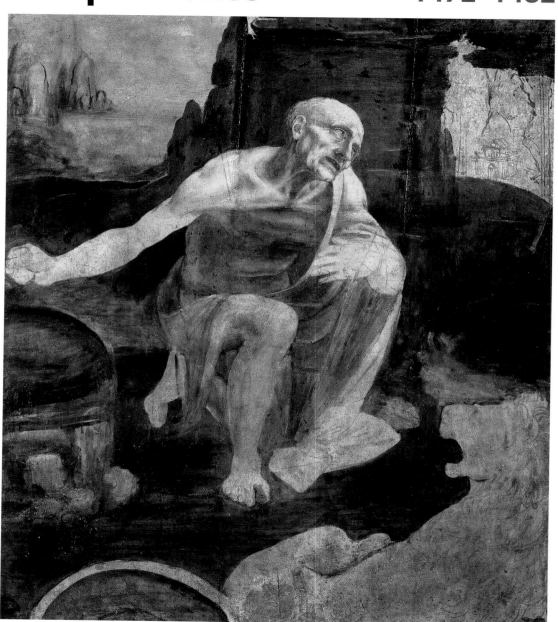

At the age of 20, Leonardo was officially accepted into the artists' gild of Florence. Although he was now able to accept contracts independently, he continued to work in Verrocchio's studio. His contemporaries described him as an unusually handsome man with a pleasant, friendly personality, who was always carefully dressed. His main interest during these years was painting. As well as producing pictures of the Madonna, a favorite subject of the age, he painted his first portrait and was ultimately to start on his first great altarpiece, the *Adoration of the Magi*. Although it is difficult to form a judgment on many of his early works because of their poor state of preservation or, like *St. Jerome*, because they were not finished, the unusual and innovative quality of his art was already evident; Leonardo, like no other artist, was able to invest his figures with an inner vitality.

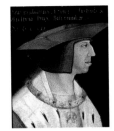

Maximilian I

Sandro Botticelli, Self-portrait

1474–1477 Burgundian Wars: The Swiss Confederation, which had existed since 1291, successfully defends its territory from the expansionist Duke Charles the Bold of Burgundy. After Charles's death on the battlefield, Burgundy falls to France.

1475 The painter Michelangelo Buonarroti is born.

1477 The painter Titian is born. The successor to the German throne, Maximilian of Austria, claims the lands of Charles the Bold; there is a confrontation with France.

1481 The Inquisition is introduced to Spain.

1482 At the Peace of Arras, the German-French conflict is settled and the division of the disputed territories is decided.

1472 Leonardo becomes a member of the Florentine painters' gild of the Company of St. Luke.

1476 Together with four other men, Leonardo is charged with indecency; the charge is withdrawn soon after.

1478 Leonardo works on two pictures of the Madonna. He receives a contract for an altarpiece for the Chapel of St. Bernard in the Palazzo Vecchio, which is later completed by Filippino Lippi.

1479 Leonardo moves into his first apartment. He draws the hanged assassin of the Medici, Bernardo di Bandino Baroncelli.

1481 Commission from the monastery of S. Donato for a Scopeto for an altarpiece, the *Adoration of the Magi*. The picture is never finished.

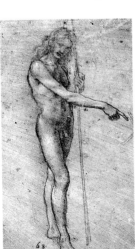

Opposite:
St. Jerome in the Wilderness,
1479–1481
Oil on wood, 103 x 75 cm
Vatican, Pinacoteca Vaticana

Right:
John the Baptist as a Boy, ca. 1478
(detail)
Drawing
Windsor, Royal Library

A Mysterious Portrait

Sandro Botticelli and Pietro Perugino – who later became Raphael's teacher – were accepted into the Company of St. Luke, the gild of Florentine painters, in the same year as their studio colleague Leonardo. From the outset, Leonardo worked unusually slowly and created relatively few pictures in comparison with his fellow painters. Besides painting, he occasionally sculpted clay heads of women and children, and learned how to sing and play the lute. Perhaps the most fascinating picture he painted in his early days in Florence was the portrait of Ginevra Benci. In the early Renaissance, portraiture had become an important new branch of art and the main source of

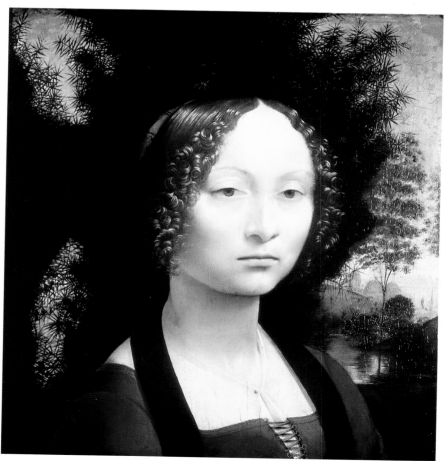

Portrait of Ginevra Benci, ca. 1478–1480
Oil and tempera on poplar wood
38.8 x 36.7 cm
Washington, National Gallery of Art

The pale face of the young woman is framed by fine locks, which combine with the dark juniper bush and the landscape in the background to form a whole. The portrait is one of the first in Florence to fuse figure and background together to create a unified effect. The lower part of the picture in which the interlocked hands of the subject could be seen was cut off; the painting originally had a long vertical format, indicated by the plant ornament on the reverse side of the painting.

commissions were the cultivated and prosperous middle classes.

The dark juniper bush in the picture – *ginepro* in Italian – is a play on the young woman's first name. The emblem of her admirer, the humanist Bernardo Bembo, is depicted on the back of the panel. Ginevra Benci (1457–1520) was famous in Medici circles for her lyric poetry and impeccable virtue. Leonardo gave her melancholy features a porcelain delicacy reminiscent of Flemish painting, which had entered the Florentine art world through the activities of the city's merchants. Most Florentine portraits of women had showed the subject in profile, but here she turns to face the viewer. Legend has it that Leonardo fell in love with this young beauty – an improbable event. "It is doubtful whether Leonardo ever embraced a woman in passion," wrote the psychoanalyst Sigmund Freud in the twentieth century. Around 1560 the Italian writer Giovanni Paolo Lomazzo (1538–1600) had already claimed that Leonardo was given to pederasty. Homosexuality was not unusual in Florence at the time – especially amongst artists and intellectuals – although it was officially illegal. Together with three other men, Leonardo was charged in 1476 with committing an indecent act with a youth by the name of Jacopo Saltarelli. The charge was later withdrawn because of lack of evidence.

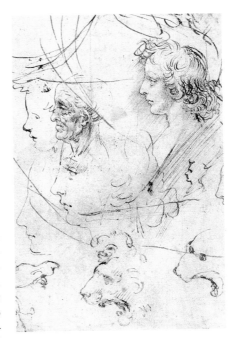

Figure study, ca. 1480 (detail)
Drawing
Windsor, Royal Library

This sketch made with quick pen strokes shows Leonardo's experiments with the various possibilities of profiles. The female heads may have been drawn from a model. The various animals depicted with gaping mouths in the lower part of the page convey a wild and untamed impression.

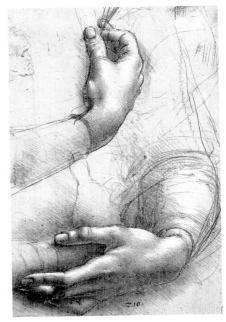

Study of hands,
1478–1480
Silver point drawing
21.5 x 15 cm
Windsor, Royal Library

Here, Leonardo has drawn the interlocking hands of a woman twice: at the bottom he has concentrated on the depiction of the left hand. Above this is a study of the effects of light and shade on the right hand, which holds a ribbon between its fingers. The study has been connected with the *Portrait of Ginevra Benci*.

The Early Madonna Pictures

The corner of a ragged piece of Leonardo's notepaper reveals the barely legible remark: "… in 1478 I began the two Madonnas …". Generations of art historians have scoured Leonardo's notebooks and loose-leaf sketch books like detectives for such clues, as few other sources of information about his work exist.

One of the pictures mentioned by Leonardo is almost without doubt the so-called *Madonna Benois* in St. Petersburg. Other Madonnas from this period have also been attributed to Leonardo. Some, such as the *Madonna, Child, and Cat* exist only as drawings.

The *Madonna Benois* is now just a shadow of its former self. The picture was greatly damaged by its transfer from wood to canvas in the nineteenth century. Furthermore, the subtlety of its technique has been obscured by dirt and added layers of paint. In the window, for example, which now seems much too bright, there was almost certainly originally a landscape. In spite of this, the picture is considered Leonardo's most interesting early painting of the Virgin.

Smaller depictions of the Madonna were very popular in Italy at the time; numerous examples executed both as paintings and as reliefs have survived from Verrocchio's circle alone. Like the *Madonna Benois* they served as private devotional pictures for pious owners. In these works the Virgin does not appear as the majestic queen of heaven, but rather as a loving mother who is often only separated from the viewer by a balustrade.

Leonardo took up this artistic tradition and developed it still further. Never before had the figure of the Virgin been depicted with such freshness and naturalism as in

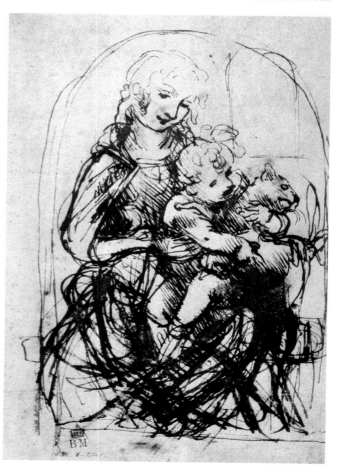

The Madonna, Child, and Cat, 1478
Pen and ink drawing (facsimile)
13.2 x 9.5 cm
Florence, Gabinetto dei Disegni e delle Stampe

Both Madonna and Child have been depicted in a free sketch. Their movements seem full of life but harmonious.

Madonna with a Fruit Bowl, ca. 1478
Metal point, pen, and ink
35.8 x 25.2 cm
Paris, Musée du Louvre

the *Madonna Benois*; with all the seriousness and concentration of an infant, the Christ child grasps the flower which his mother holds out to him.

Leonardo, himself not a practicing Christian, focused the scene on the theme of the intimacy of mother and child. In Florence he was able to study young mothers playing and laughing with their children daily. He recorded these observations in sketches, and developed complete pictorial compositions from them in which his main aim was to capture the immediacy of typical movements that expressed the relationship of the figures to each other. His sketches make these gestures seem effortless and spontaneous.

Unfortunately, some of the original freshness was lost in the transition to the painted medium as Leonardo structured the composition down to the final detail. The hands of the mother and child, for example, meet at the intersection of the composition's diagonals.

The oblique arrangement of the figures is typical for Leonardo, a technique which reinforces the three-dimensional effect of the bodies and

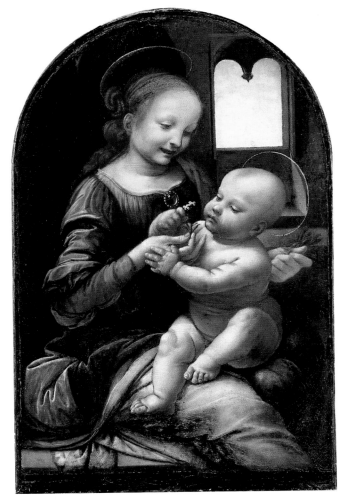

is evidence of Leonardo's training in sculpture. The spontaneous, open smile of the Madonna lends the picture a particularly lively expression; a slight smile, sometimes merely hinted at, became virtually a signature of Leonardo's later work.

Madonna Benois, ca. 1478
Oil on wood, transferred to canvas
48 x 31 cm
St. Petersburg, The Hermitage

The muted coloring is characteristic of Leonardo.

New means of expression

In March 1481 Leonardo signed a contract with the monastery of S. Donato a Scopeto for a large altarpiece to be delivered within 30 months. The monks never received the work, and 15 years later they gave the contract to Filippino Lippi.

Despite never being completed, the *Adoration of the Magi* occupies a key position in Leonardo's early work. Now at the end of his twenties, he was no longer a novice in the profession, and could look back on a ten-year career as an artist. In this picture he formulated for the first time his new artistic ideas for a bold painting on a large scale. The Madonna is seated in the center of the picture, the Christ child on her lap. She is the tranquil center of a composition full of passionately animated figures. Representing humanity, the three kings and various other figures approach the Son of God in order to express their reverence, emotion, and astonishment. Their expressive gestures reflect a broad spectrum of human reactions in a work pervaded by a new type of psychology.

Many of the picture's elements, gestures, and portraits feature in Leonardo's later work, such as the mysterious group of armed riders in the background who reappear in the *Battle of Anghiari* (page 59). For the first time, Leonardo organized the figures into a pyramid, a compositional scheme that was later to assume great significance in Renaissance painting.

It may be that Leonardo did not complete the painting because he did not believe he was capable of living up to his own expectations. Or was he sidetracked by other projects? The *non finito*, the unfinished picture, was not at that time an autonomous art form as it was later to become in the nineteenth century. But it was one of Leonardo's typical traits not to complete his projects; countless pieces have been left half-finished or incomplete. After working for months on the *Adoration of the Magi* he decided to turn his back on the city of his youth: he closed his studio in Florence and made his way north to Milan.

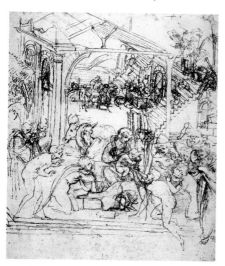

Studies of bodies and a group of figures, ca. 1478 (detail)
Drawing
Cologne, Wallraf-Richartz-Museum

Leonardo studied the expressive potential of various postures in numerous small figure sketches.

Sketch for Adoration of the Magi, ca. 1481
Pen and ink drawing (facsimile),
28.5 x 21.5 cm
Paris, Musée du Louvre, Cabinet des Dessins

This sketch is more closely modeled on the conventions used in depictions of the Adoration at the time than was the later painting. The figures of the kings are depicted nude in order to articulate their movements better. The background has been sketched freely; its perspective has not been shown correctly.

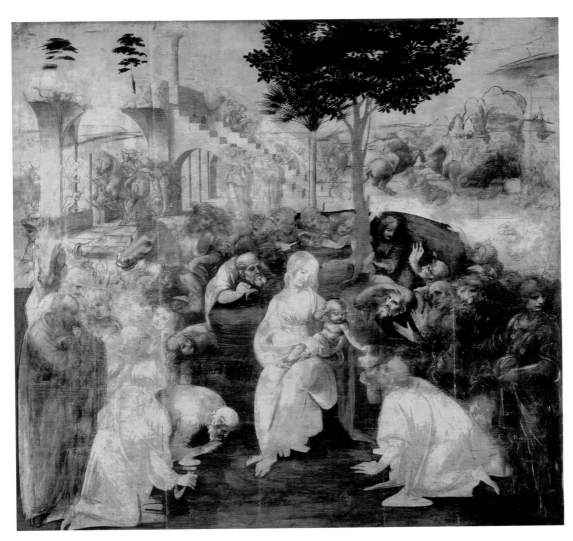

The Adoration of the Magi, ca. 1481–1482
Underpainting in oil and bister on wood
246 x 243 cm
Florence, Galleria degli Uffizi

Leonardo's methods can be readily identified in this incomplete painting. He drew figures in fine lines on the light ground of the wooden panel, and in several places he applied the base layer of paint, the purpose of which was to allow the three-dimensional articulation of shapes through light and shade. Color would then have been applied in thin layers of glaze. The artistic innovation of this process then becomes clear: it was aimed at the development of a *chiaroscuro* style, which modeled the figures from a common tone of shade instead of placing them side by side in glowing colors. Several of the picture's figures are difficult to interpret, for example the two figures that are standing in the foreground.

The Space of the Picture: Central Perspective

Masaccio
The Trinity, ca. 1425
Fresco, 680 x 475 cm
Florence, Santa Maria Novella

A picture is really a flat surface covered in paint. Since antiquity, painters have experimented with several ways of achieving the effects of space within a picture. Not until the Renaissance, however, was central perspective discovered, which allowed the illusion of a unified depth of space. This method of depicting space remained fundamental to painting until the beginnings of the Modern era. The decisive step towards central or linear perspective was taken by the Florentine sculptor and architect Filippo Brunelleschi, who belonged

to the first generation of early Renaissance artists. His discovery was employed by his friend Masaccio, whose fresco of the Trinity constructed pictorial architecture using the new method: the lines of the vault run toward a central point at the foot of Christ's cross. The height of this vanishing point corresponds to the assumed height of the viewer standing in front of the picture; the image would then appear as if one were looking into a niche in the wall. The effect of this discovery cannot be overstated enough. For Renaissance viewers, it was as though the picture were a window through which they could see a portion of the world (Lat. perspicere – to see through). Central perspective was taken up rapidly by Italian painting,

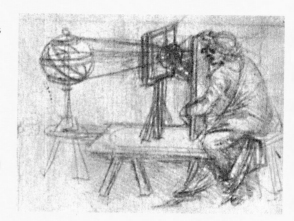

though it was not to become widely known in Northern Europe until around 1500 through the work of Albrecht Dürer. Leonardo learned how to represent perspective during his apprenticeship. His precisely constructed drawing for the painting *Adoration of the Magi* shows clearly the numerous guide lines which run from the bottom of the picture toward the vanishing point. The further objects are away from the viewer, the smaller

Ucoderon Abscisus (Perspective drawing of a geometric body for Luca Pacioli's *De Divina Proportiona*), ca. 1498
Drawing
Milan, Biblioteca Ambrosiana

Spectograph, ca. 1480
Charcoal drawing
62 x 40 cm
Codex Atlanticus I r-a
Milan, Biblioteca Ambrosiana

they appear. A fundamental problem of central perspective immediately becomes clear in this drawing: only architectural elements – ideally square objects – can be depicted in this way.

Landscapes, living creatures, and human figures on the other hand are not so simple to construct. In his book on the theory and practice of perspective, the painter Piero della Francesca set out how the human body could be considered as a geometrical body and thus reconstructed.

Perspective is nothing more than viewing a scene behind a flat, transparent piece of glass on whose surface all the objects located behind the glass have been drawn.

Leonardo da Vinci

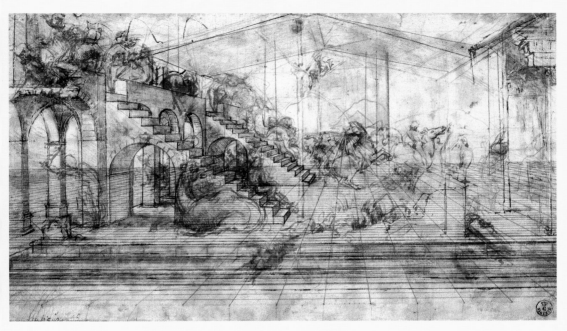

This technique was, however, exceedingly complicated. After reading Piero's tract, Leonardo abandoned his own attempt to write a manual on perspective. Several painters sought to make the task easier by means of a piece of practical equipment, the so-called spectograph, seen here in a sketch by Leonardo. The artist looked through a pane of glass at the object and then captured its outlines on the glass. Leonardo advised artists to use a similar technique to control

perspective when drawing nude models. Linear perspective did not play a significant role in his later work. He recognized that human perception was conditioned by other factors such as light and humidity, which could not be depicted by means of mathematical constructs; color and atmosphere assumed a greater importance for him. From the beginning it was clear to Leonardo that a painter could achieve the illusion of space through the correct distribution of light and shade. He examined this

relievo effect – the modeling of bodies by means of light and dark areas – with an almost scientific precision in his sketches, and went on to perfect the technique in his painting.

Perspective study of the background for Adoration of the Magi, ca. 1481
Pen, brown ink, traces of silver point and white on paper (facsimile)
16.5 x 29 cm
Florence, Gabinetto dei Disegni e delle Stampe

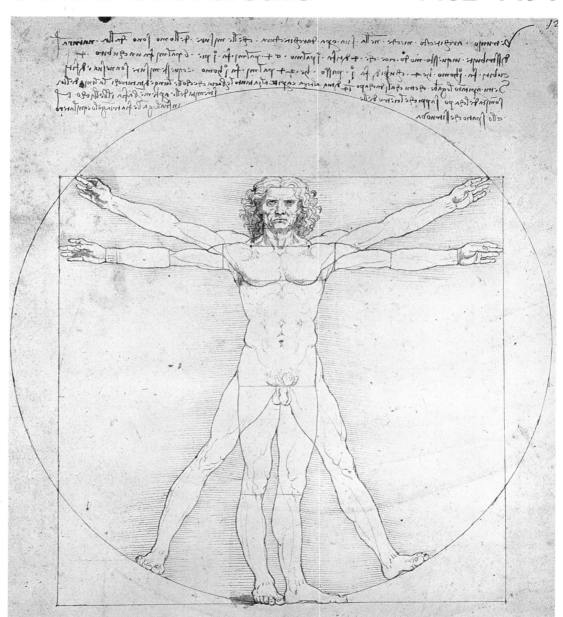

At the court of Milan, Leonardo found something his home town of Florence was not able to offer him: a financially secure existence and the chance of developing his abilities in the most diverse fields. He was active as a portrait painter and theater designer, drew architectural designs and worked on a large equestrian statue. Leonardo enjoyed being able to pursue other interests besides his artistic ones. He threw himself into solving technical problems, examined the canals in the area, and designed war machines and other inventions. Practical problems led him to ponder more fundamental questions, and he began to look into the fundamentals of mechanics or the nature of water. There were always new questions to deal with. Leonardo developed from an artist into a *uomo universale*, a universally educated man capable of unusual achievements in many areas of the arts and sciences.

Illustration from *The Hammer of Witches*

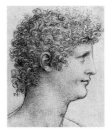

Salai as a youth

1485 The painter Raphael Santi is born.

1485 Henry VII of Lancaster returns to England from exile in France and ends the Wars of the Roses.

1487 *The Hammer of Witches* is published. The book contains directions for combating witchcraft and adds fuel to the epoch's greatest mass psychosis.

1492 Christopher Columbus lands on an island which he names San Salvador. This event enters the history books as the discovery of America. In Italy, the death of Lorenzo de'Medici leads to a power vacuum. King Charles VIII of France claims sovereignty over Naples in order to use it as a base from which to conquer all Italy.

1482 Leonardo settles in Milan, and offers Duke Ludovico "Il Moro" Sforza his services as an artist and engineer. He remains in Milan for 18 years until the Duke is overthrown.

1483 Together with the de Predis brothers he receives a commission for an altarpiece for the Brotherhood of the Immaculate Conception in Milan.

ca. 1484 Leonardo begins designing an equestrian statue for the Sforza.

1487 Participation in the competition for the dome of the Milan cathedral.

1489 Begins work on a book on human anatomy.

1493 The life-sized clay model of an equestrian statue is erected in the courtyard of the Sforza's castle.

Opposite:
Vitruvian Man, ca. 1490
Pen, ink, and pencil on paper
34.3 x 24.5 cm
Venice, Galleria dell'Accademia

Right:
Dragon emblem, 1494
(detail)
Black chalk, pen, and ink
Windsor, Royal Library

At the Court of the Sforza

In Leonardo's day, Italy was divided into a series of small states, of which the Papal State, Naples, and Venice were the most powerful. The various princedoms and city republics formed an ever-shifting set of alliances and were constantly at war with one another in an effort to expand their spheres of influence. Military confrontations were a fundamental part of life. The ruler of Milan was Duke Ludovico Sforza (1452–1508) who, because of his dark complexion, was called "Il Moro," the Moor. The Sforza were not an old princely dynasty. The father of Ludovico il Moro served as a *condottiere*, a mercenary leader, before seizing power in Milan and bringing to an end the 150-year-old

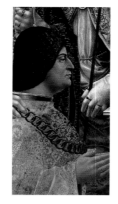

Master of the Pala Sforzesca
Altarpiece of the Sforza, ca. 1495
(Detail with the portrait of Ludovico il Moro)
Oil on canvas
Milan, Pinacoteca di Brera

The Sforza Castle, photo

rule of the Visconti family. Ludovico il Moro was a typical Renaissance prince, a man of action, hungry for power and with an appreciation of the arts. At his luxurious court he competed with the magnificence of the Medici in Florence. He did not gather artists and scholars around him merely for his own entertainment, but also to boost the reputation of the Sforza house. If an early biography of Leonardo from the sixteenth century is to be believed, the artist originally arrived at the court of the Sforza not as a painter but as a musician: "When he was thirty years old, he was sent by Lorenzo the Magnificent (de' Medici) to the Duke of Milan in order to present him with the gift of a lute, which Leonardo was able to play masterfully." This bizarre instrument of silver in the shape of a horse's skull was said to have been designed by Leonardo himself. By conveying the gift personally, Leonardo had an excellent opportunity of gaining access to the court. Apparently Leonardo thought it advisable not to rely solely on his reputation as an artist if he wanted to gain a foothold in Milan. In order to assert their power, princes such as Ludovico il Moro were dependent on good engineers. Leonardo therefore prepared a written application to the Duke in which he portrayed himself as the skillful inventor of war machines, prefabricated bridges and fortifications, although in fact his practical experience as an architect and engineer was quite limited.

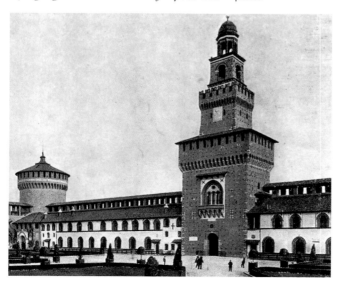

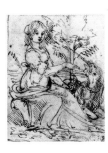

Lady with a Unicorn,
ca. 1490
Drawing
9.7 x 7.5 cm
Oxford, Ashmolean
Museum

"In times of peace," he added, he was able to make paintings and sculptures "as well as any other man."

Milan was a city of 200,000 people, and at first Leonardo lived with his colleagues, the de Predis brothers, who operated a studio near the Porta Ticinese. In the course of the next few years Ludovico il Moro charged him with a variety of tasks, finally naming him *pictor et ingeniarius ducalis*, the Duke's own painter and engineer. He portrayed the Duke's beautiful young mistress, Cecilia Gallerani, with an ermine on her arm. The court poet Bellincioni praised the portrait in a sonnet, calling it so life-like that the subject looked as though she were listening. Leonardo also designed decorations for festivals and stage sets, and drew picture-puzzles and allegories. In the castle of the Sforza dukes, a Renaissance fortification with impressive towers, he painted decorative murals, some of which have been preserved. He filled page after page of his sketchbooks with technical and military drawings; these included designs for fountains, heating plants, and garden pavilions. These diverse projects stimulated Leonardo's inventive spirit to create more and more new ideas; that he barely had time to paint because of the demands of all his other tasks and interests does not seem to have disturbed him unduly.

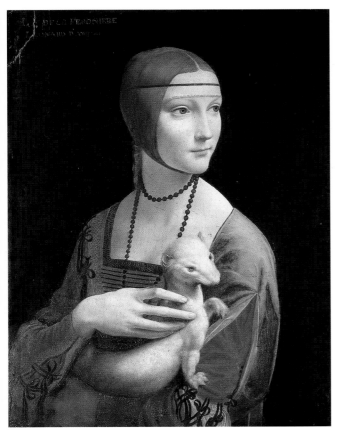

Lady with an Ermine (Cecilia Gallerani),
1483–1490
Oil on walnut wood
54.8 x 40.3 cm
Krakow, Czartorsky Muzeum

The portrait is probably of the mistress of Duke Ludovico il Moro, a speculation fueled by the ermine that the young woman holds gently on her arm: the animal was the Duke's emblem. At the same time the creature is a play on the subject's name, Gallerani – the Greek word for ermine is *galé*. In spite of its poor state of preservation – the background and the hair have been roughly painted over – the painting is an excellent example of Leonardo's portraiture.

The Equestrian Monument for the Sforza

While he was still living in Florence, Leonardo had heard of the great monument project of the Milanese dukes. Ludovico il Moro's predecessor and brother had intended to erect an equestrian statue to the founder of the dynasty, Francesco Sforza, but no one could be found who was capable of realizing this in bronze. Ludovico il Moro resurrected the plan, not least because he wished to emphasize publicly his family's claim to power. The monument was to be much greater than life-sized – indeed larger than any other equestrian statue in Italy. Leonardo was fascinated by this project, and in his letter of application to the Duke he had already offered to take over its

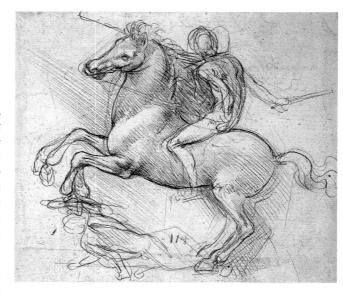

execution. The Florentines were considered experts in the difficult art of bronze casting; Leonardo had witnessed the creation of the model for the *Equestrian statue of the mercenary leader Colleoni* in Verrocchio's studio. Along with Donatello's *Gattamelata Monument*, it was the grandest equestrian statue of the early Renaissance. The Classical age had considered equestrian statues the most sublime way to honor rulers, and the Renaissance took up this tradition once again. Leonardo studied the antique equestrian statue of the *Regisole* in Pavia and noted: "The horse in Pavia is especially remarkable for its movement. Its trot is almost the same as the natural movement of a living horse." He undertook intensive studies of nature, drew the finest horses, and observed

Design for the Sforza Monument,
ca. 1485–1490
Silver point on bluish paper
14.8 x 18.5 cm
Windsor, Royal Library

Leonardo abandoned this design because the heavy mass of the horse could not be balanced on the hind legs.

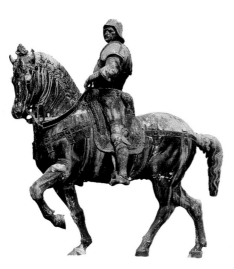

Left:
Andrea del Verrocchio
Equestrian statue of the mercenary leader Colleoni,
1479–1488
Bronze statue
Height 3.96 m
(without pedestal)
Venice, Campo di San Giovanni e Paolo

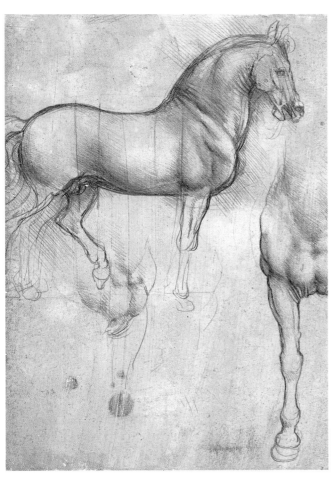

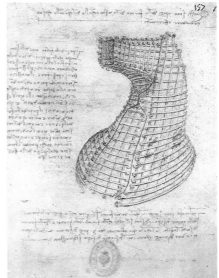

Manuscript page on the Sforza Monument, ca. 1491
Red chalk drawing
21 x 15 cm
Codex Madrid I, fol. 157r
Madrid, Biblioteca Nacional

A number of technical studies and notes prove the seriousness with which Leonardo approached the problems of bronze casting. In order to be able to cast the horse in a single piece, he developed a completely new method of casting. The drawing shows the iron framework for the mold of the horse's head.

Study of horses,
ca. 1490
Silver point on bluish paper
21.4 x 16 cm
Windsor, Royal Library

This study is evidence of the intensity of Leonardo's study of equine anatomy in the stables of Milan's aristocracy.

equine anatomy and proportion in the stables of the Milanese nobility. Initially he planned to depict the horse rearing up to give it the greatest expression of concentrated energy and power. This bold design failed for technical reasons, and Leonardo finally decided to depict the horse pacing. In 1493 the life-sized clay model was erected in the courtyard of the Sforza castle where contemporaries greeted it with enthusiasm. The casting of this enormous monument presented an unprecedented technical challenge. After all the preparations had been completed, however, Leonardo was informed that Ludovico il Moro had given all the available bronze to his brother-in-law, Ercole d'Este: a war threatened and it was needed for making cannon.

Raphael
Bramante (Study for the Dispute), 1509
(detail)
Silver point on paper with a green ground
Paris, Musée du Louvre

The painter and architect Bramante (1444–1514) was a member of Leonardo's circle of friends in Milan. Both men almost certainly discussed their ideas on architecture. Like Leonardo, Bramante was an enthusiastic proponent of central plan structures. Unfortunately, only a few designs remain from his period in Milan. He later worked at the Papal court in Rome where he began the reconstruction of St. Peter's, and where he built the most important central plan structure of the Renaissance – the Tempietto near San Pietro in Montorio.

Pupils, Friends, and Scholars

Amongst Milan's artists and scholars Leonardo met notable people with whom he was able to exchange ideas, and this circle of friends stimulated him even further. Through his contact with the architect Bramante, Leonardo developed his own architectural ideas, and together with Lucia Pacioli, one of the leading mathematicians of his age and whose book on proportion he illustrated, Leonardo devoted himself to the study of geometry. The search for harmony and ideal proportions was not restricted to a single discipline; it was a task which occupied painters and architects, musicians and mathematicians in the course of the Renaissance. In order to be able to read Classical authors, whose work formed the basis of all scholarship,

Leonardo taught himself Latin. He not only sought out the company of intellectuals, but also talked with experienced artisans in order to learn more about building canals or the techniques of masonry.

During his time in Milan Leonardo began to record his theories and ideas in greater detail, covering thousands of pages with sketches and notes written in minute handwriting. Like many left-handed people, he found it convenient to write from right to left in a mirror script so as not to smear the ink. His notebooks contain not only observations on nature, technical and artistic studies, but also personal remarks, accounts, and lists of addresses, which provide information on his interests and contacts.

Ludovico il Moro had made rooms available for Leonardo in the Corte Vecchia, the old Residence, where he set up his studio, and where he also had space for developing his

Anonymous
Luca Pacioli with a Pupil, 1495
Oil on canvas
99 x 120 cm
Naples, Museo e Gallerie Nazionale di Capodimonte

The monk Fra Luca Pacioli was a friend of the painter Piero della Francesca, whose theories on perspective influenced his own writings. This picture shows him surrounded by geometrical tables and objects.

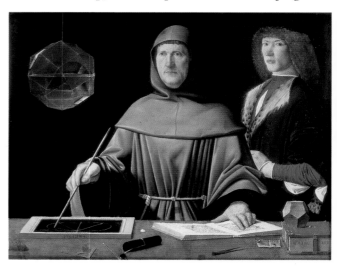

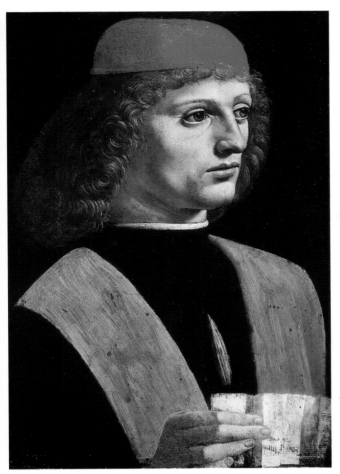

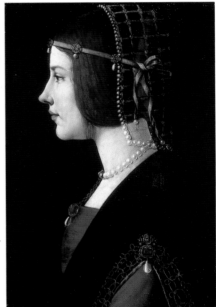

Below:
Anonymous
Portrait of a Lady,
ca. 1480
(detail)
Oil on canvas
Milan, Pinacoteca
Ambrosiana

This portrait was once attributed to Leonardo or his colleague Ambrogio da Predis. But neither the artist nor the young woman in the picture, once thought to be Beatrice d'Este, the wife of Ludovico Sforza, can be identified.

Portrait of a Musician, ca. 1490
Oil on wood
44.7 x 32 cm
Milan, Biblioteca
Ambrosiana

The only known portrait of a man by Leonardo depicts a Milanese musician, possibly his friend Franchino Gaffurino.

technical inventions. The artist now took assistants and pupils into his workshop, amongst them Marco D'Oggiono and G. A. Boltraffio, who absorbed his artistic style and sometimes incorporated entire compositions from Leonardo into their own work.

A special position in the workshop was occupied by a young lad called Salai, whose real name was Giacomo Caprotti; he was taken on by Leonardo in 1490 at the age of ten. Salai means Little Devil and Leonardo's charge was true to his nickname. Salai stole valuable silver points from the other artists, and misappropriated money from Leonardo to buy aniseed sweets. Despite such mischief Leonardo was always particularly fond of the boy.

Leonardo as Engineer: Inventions and Constructions

The almost 6000 pages of Leonardo's journals and notebooks are filled with countless sketches on mechanics and science; in fact, there are far more technical drawings than there are artistic designs: his work as an engineer was a field of activity that he took very seriously. It used to be thought that Leonardo's technical inventions marked him out as a brilliant exception; in fact, he and the other Renaissance artist-engineers were part of a longer tradition. One of the most prominent engineers of the age, Francesco di Giorgio Martini (1439–1511) from Siena was painter, architect, hydrologist, and inventor. Leonardo knew him personally and studied his work. During his early years in Florence, Leonardo had already displayed a keen interest in engineering.

He drew sketches of cranes and the lifting equipment that the architect Filippo Brunelleschi had developed in the first half of the fifteenth century in order to realize his audacious plan for the dome of Florence cathedral (page 37). During the 1480s Leonardo worked assiduously on technical problems, spurred on by the expectations of his clients. His first inventions from this time are fantastic war machines which were partly inspired by depictions from antiquity. He developed multi-barreled firearms, an armored car with an engine, portable prefabricated bridges, and enormous fighting machines such as the *Large crossbow on wheels*, which was operated by one man. It is difficult to say whether such equipment could have been built, given the resources

available at the time – Leonardo's unique imagination was able to make even the most improbable ideas seem feasible. His construction sketches are so precise that many of his machines can easily be reconstructed as models. The extraordinary vividness of these technical sketches lends them the beauty of artistic drawings. Leonardo's technical work was often inspired by everyday problems for which he sought an improved solution. He developed more efficient machines for the production of textiles – an economic activity of great importance both to Milan and Florence. He also noted down eccentric ideas such as a spit that would be turned by the action of hot air, or a

Machines for lifting weights, 1503–1504 (detail)
Pen and ink drawing
Codex Atlanticus, Folio 80-b
Milan, Biblioteca Ambrosiana

mechanical apparatus for the studio that would enable large paintings to be lowered into the floor. He was particularly fascinated by hydraulics. The area around Milan was crisscrossed by canals, making the water power harnessed by waterwheels and irrigation projects of strategic importance. His

Left:
Model of an automobile
after plans by Leonardo da Vinci
Amboise, Le Clos Lucé

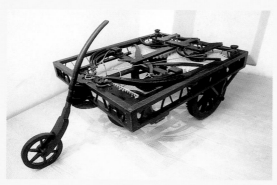

Drawing of cogs on a manuscript page, ca. 1490 (detail)
Drawing
Madrid, Biblioteca Nacional

increasing technical knowledge led Leonardo to believe that he could make the ancient dream of manned flight come true (page 50). Others of his inventions also seem like visions that were not to come true for hundreds of years such as his *Model of an automobile*, which was to be driven by a type of clockwork motor. In contrast to his contemporaries, Leonardo viewed machines in a systematic way on the basis of their individual components. He examined the functions of the cog, the screw, the spring, and the block and tackle – the most important elements of fifteenth-century technology. Consistent in his logic, he investigated the fundamental principles of machines and did not

restrict himself to their practical applications. In systematic experiments he examined the effects of weight and force, the nature of the flow of water, and the laws of leverage. His unquenchable thirst for knowledge led him to ask questions which perhaps no other individual had ever asked up until that time. Truth for him was derived from experimentation; Leonardo was therefore a scientist as much as a technician. On several occasions he intended publishing his insights in the form of written treatises, but new observations constantly diverted him so that he never had the time to organize and edit his notes. Leonardo's technical works therefore consists of a huge compendium of disorganized sketches and written remarks. It is the

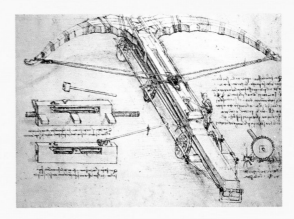

single most important source of information on Renaissance technology, and one that conveys an excellent impression of Leonardo's inventiveness.

Large crossbow, ca. 1499
Pen and ink drawing with wash
Codex Atlanticus, Folio 53 verso-a-b
Milan, Biblioteca Ambrosiana

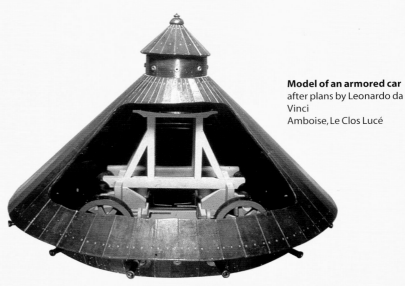

Model of an armored car
after plans by Leonardo da Vinci
Amboise, Le Clos Lucé

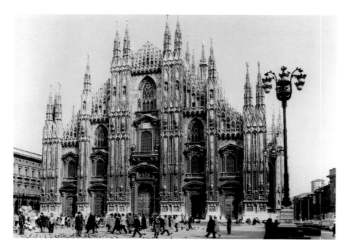

Milan Cathedral,
photo
After St. Peter's, Milan Cathedral is the largest church in Italy. This richly ornamented structure was begun in 1386 and is the only structure in the pure Gothic style in the whole country. Leonardo took part in the competition for the dome, which was to be erected over the cathedral crossing.

Architectural Projects

The most controversial building project in Milan in Leonardo's day was the gigantic cathedral whose construction had begun a century earlier. It was to be crowned by a dome which had caused engineering as well as artistic problems. The site office was host to a constant succession of architects both from Italy and abroad. Leonardo also tried his hand at the project; he submitted his own suggestions and had a model made. Although he had no experience in architecture, he was soon arguing like a seasoned practitioner about thrusts and the load capacity of arches. Ultimately, however, a rival

Design for an ideal city, ca. 1485
(detail)
Pen and ink drawing
Manuscript B,
Folio 16r
Paris, Bibliothèque de l'Institut de France

After the plague of 1484–1485 Leonardo drew the logical conclusion from the catastrophically unhygienic conditions in densely built Milan. His ideal city was to consist of high-rise buildings; subterranean canals would provide water and serve as transport routes, and the upper levels were to be free of dirt and work.

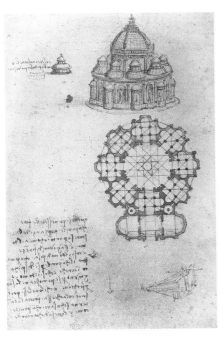

Central plan church with dome and eight chapels, ca. 1484 (detail)
Pen and ink drawing
Codex Ashburnham 2037, Folio 5 v
Paris, Institut de France

Leonardo developed countless ideas for central plan churches with domes, chapels and niches in his sketches. The ground plans were based on geometric forms such as circles and squares. For Renaissance architects the form of central plan structures embodied an ideal of harmony and was considered a symbol of the divine.

beauty of geometrical harmony. Leonardo's own tendency toward utopian ideas is also seen in his urban planning designs. The ideal city was a favorite project for a number of Renaissance theorists. The Milanese architect Filarete designed an ideal city called Sforzinda whose star-shaped layout was supposed to express beauty and order. Leonardo on the other hand attempted to combine both aesthetic and practical considerations in his plans for an ideal city. None of his architectural schemes were ever put into practice, but more of his architectural sketches have survived than from any other architect of the age. He developed the modern form of architectural drawing showing ground plan, elevation and perspective.

design was selected. Leonardo was not the only painter at the time to be active in architecture. His friend Bramante, one of the most important architects of the Renaissance, had also begun his career as a painter; even Michelangelo and Raphael distinguished themselves as architects. Leonardo developed innovative fortifications for Ludovico il Moro, designed garden pavilions or sketched fantastic ideas such as a 130-m high tower for the Sforza castle. He was especially fascinated by central plan architecture, whose symmetrical structures focused their individual parts on a single central point. Leonardo's many designs for central plan churches reflected the general enthusiasm of the Renaissance for the

Studies for the dome on the crossing of the Milan cathedral, ca. 1484 (detail)
Drawing
Codex Atlanticus, Folio 266 r
Milan, Biblioteca Ambrosiana

Leonardo planned a self-supporting dome similar to Brunelleschi's Dome of the Florentine Cathedral. The design was to conform to the Gothic style of the cathedral, but would have been difficult to construct, as the 50-m high dome was to have rested on only four narrow piers.

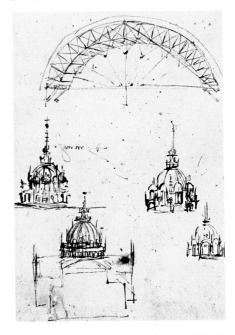

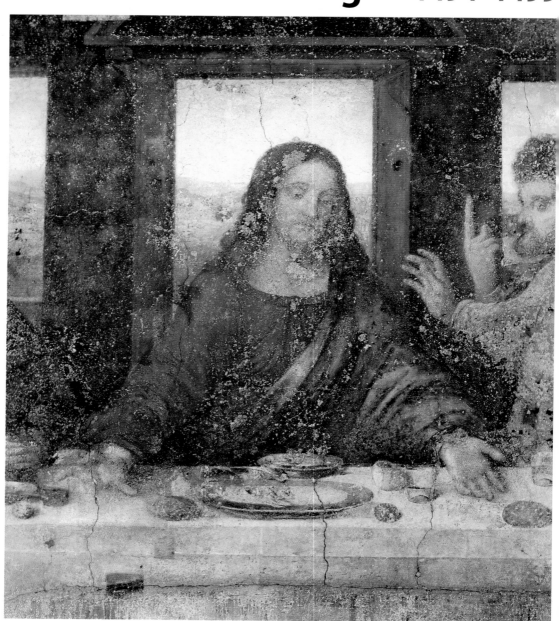

While in Milan Leonardo pursued his scientific and technical studies with the creativity of an artist; at the same time, he increasingly came to see painting as a scientific discipline. The ultimate goal of all this study – in anatomy and biodynamics, botany and zoology, even geology and meteorology – was to achieve the "perfect" painting. During this time he made paintings that are among the most important artworks ever created. It was above all the *Last Supper*, painted for the Milan monastery, which established his fame. This highly dramatic but entirely harmonious picture revolutionized conventional painting. The *Last Supper* became a model for future generations of artists – even though it began to peel almost as soon as it was finished.

Vasco de Gama

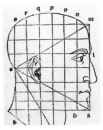

Proportion study for the head of a man

1493 The German doctor and philosopher Paracelsus is born.

1498 Portuguese sailor Vasco da Gama reaches India by sea, thereby laying the foundations for Portugal's colonial expansion into the Indian Ocean. Albrecht Dürer achieves fame with his wood cuts on the *Apocalypse*.

1498 The penitential preacher Savonarola is burned at the stake in Florence.

1495 Leonardo begins work on Ludovico il Moro's commission for the *Last Supper* in the monastery of Santa Maria delle Grazie in Milan. He also continues to produce technical constructions, and architectural and geometric studies.

1497 Ludovico il Moro urges Leonardo to complete the *Last Supper*.

1498 Leonardo completes work on the *Last Supper*.

1498 Leonardo decorates a hall in the Sforza castle for Ludovico il Moro with murals and ceiling paintings.

1499 In October the French under Louis XII march into Milan. Ludovico il Moro is overthrown.

Opposite:
The Last Supper, 1495–1497 (detail)
Oil and tempera on masonry
Milan, Santa Maria della Grazie

Right:
Armored car and scythed chariot, ca. 1490
Drawing
London, British Museum

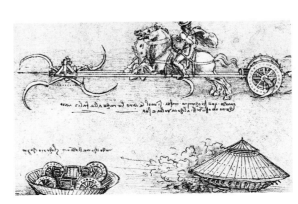

The Madonna of the Rocks

This painting is still a riddle to present-day scholars; its provenance is unexplained, a problem compounded by there being two versions of the *Madonna of the Rocks*. At the very beginning of his Milanese period in 1483 Leonardo, together with the de Predis brothers, had signed a contract for an altarpiece with the Brotherhood of the Immaculate Conception. Leonardo was to paint the central panel of the altarpiece while his colleagues were to take responsibility for the side panels and the gilding of the carved frame. According to the contract,

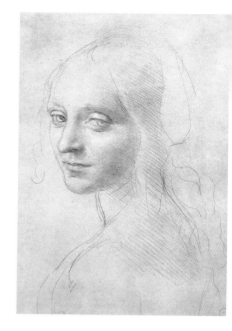

Study of the angel for the *Madonna of the Rocks*, ca. 1483
Silver point on brownish paper (facsimile)
18.2 x 15.9 cm
Florence, Gabinetto dei Disegni e delle Stampe

This study for the head of an angel is one of the finest of Leonardo's drawings; the features have been modeled in a subtle yet animated way. The lines of hatching running from the upper left to the bottom right are characteristic of Leonardo's left-handed technique.

Leonardo and his workshop
The Madonna of the Rocks, ca. 1490–1508
Oil on wood
189.5 x 120 cm
London, National Gallery

The coloring of this second version of the picture is cooler; light and shade are emphasized more strongly. Because Leonardo had abandoned the mysterious pointing gesture of the angel from the first version of the painting, the composition seems more conventional.

Leonardo's painting was to depict "our Mother of God with her Son and two prophets, executed in oil with the utmost care"; however, he apparently disregarded this rather conventional pictorial program. His *Madonna of the Rocks* – the title was not established until much later – shows the Virgin and Child with John the Baptist and an angel in a rocky landscape. Leonardo did not deliver the painting within the required eight months, and a legal wrangle ensued which was to last 15 years. In the meantime Ludovico il Moro sent the finished painting abroad, probably as a state gift, so that Leonardo had to create a second version with the assistance of his workshop.

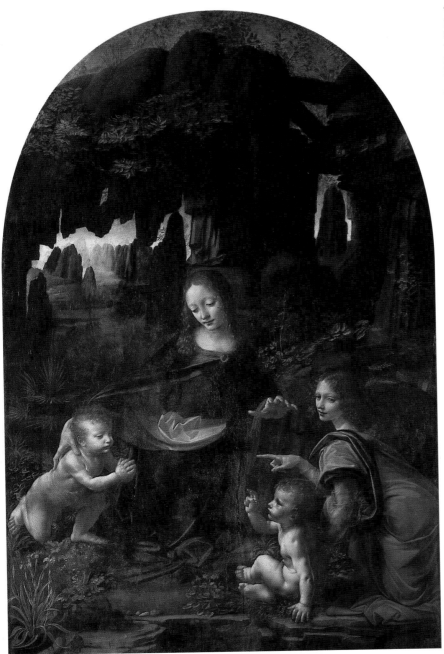

The Madonna of the Rocks, 1483–1490
Oil on wood
199 x 122 cm
Paris, Musée du Louvre

A Christian legend relates how the infant Christ was visited in a cave by John the Baptist when he was the same age. In Leonardo's painting the infant John worships Christ who answers with a gesture of blessing. The Virgin raises one hand protectively over the Christ child while embracing John with the other. This gestural play is unusual and difficult to interpret. The angel's appearance and his own pointing gesture create a relationship with the viewer, but it is not clear what the message is that the angel wishes to convey. The tranquil, mysterious atmosphere of the picture is heightened by the dim lighting and fantastic setting of the caves. Although the plants and rocks are depicted naturalistically, the scene has an unreal and alien effect.

Nature Studies: Plants and Animals

When Leonardo made a list of all his studies and paintings while he was in Milan, he included "many flowers drawn from nature." These may have included the beautiful *Drawing of a Lily* which he had made as a young painter in Florence for his painting of the *Annunciation* (page 14). In this painting the lily serves as a symbol of the Virgin's purity, but it is also a perfectly naturalistic depiction of a plant. While the painters of the Middle Ages had traditionally relied on books of patterns for their renderings of plants and animals, Renaissance artists studied these motifs directly from nature. For his painting of the *Madonna of the Rocks (page 40)* alone, Leonardo must have made numerous studies of plants. He placed great importance on recreating the typical features of individual plants in his drawings, and they can often be correctly identified as a result; in his writings he constantly referred to

Nature as his greatest teacher. Leonardo's interest in botany did not just extend to preparatory studies for his paintings. On walks through the mountains he examined trees, flowers, and grasses for their various forms, and he collected plants and made wax casts of leaves in order to study the patterns of their veins more closely. In his *Trattato della Pittura*, a treatise on painting published by his pupil Melzi after Leonardo's death, he wrote: "The further one descends to the foot of the mountains, the mightier the trees become, the denser their foliage and branches; and their shades of green are as diverse as the types of trees …; various is the arrangement of their boughs, their branches and leaves vary in their density as do their shapes and heights: some have thin branches like the cypress … others spreading broadly like the oak and the chestnut; some have tiny leaves, the leaves of others are more dispersed like those of the juniper or the plane tree…" Leonardo

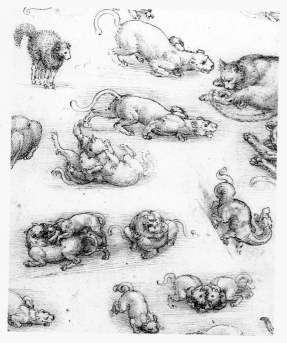

Study of cats and a dragon, 1506
Pen and ink drawing, washed
27 x 21 cm
Windsor, Royal Library

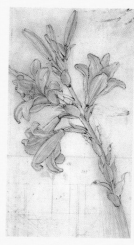

Plant study (drawing of a lily), ca. 1475
Black chalk, pen and ink with brown wash, highlighted in white
31.4 x 17.7 cm
Windsor, Royal Library

drew conclusions about the inner processes of plants from their external appearance. This understanding of the structure of plants is also expressed in his drawings. In his study for the *Star of Bethlehem* one can clearly see how Leonardo has captured the characteristic form of the flower, and yet stylized it at the same time.

The immediacy of his plant studies does not allow them to become merely

... Nature takes so much pleasure in variety, ... that even amongst trees of the same type not a single one can be found which resembles any of the others ... Therefore take heed of this and vary as much as you can.

Leonardo da Vinci

lifeless specimens – rather, they are filled with vitality. Animals assume a less prominent role in Leonardo's work than do plants, the exception being the numerous studies of horses he completed for his equestrian statues. As if for pleasure, and without any firm notion of using them later, he would occasionally fill a page with sketches of animals, such as his studies of cats in various positions. Closer inspection reveals a dragon amongst these

playfully frolicking felines, which seems just as lifelike as the "real" animals.

Leonardo's interest in and affection for animals was noticed by his contemporaries. Vasari reported that: "Often, when he was passing through public squares where birds were being sold, he took them out of the cages with his own hands, paid the dealer the required price and then let the birds fly free in order to restore their lost liberty." His friends were also

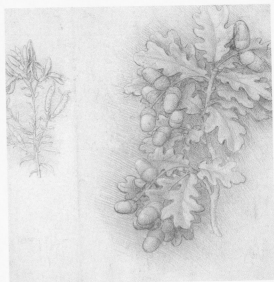

astonished that he rejected meat, and lived on a purely vegetarian diet.

Leonardo's literary texts also reveal his special relationship with animate nature. In short fables he wrote of trees or animals which were capable of feeling pain like humans: "The fig tree, which bore no fruit, was ignored by everyone. So it brought

Plant study (branch with acorns), ca. 1506
Red chalk drawing on reddish paper, white highlights
18.8 x 15.4 cm
Windsor, Royal Library

forth fruit, because it wanted to be praised by people; but they broke its boughs and destroyed it."

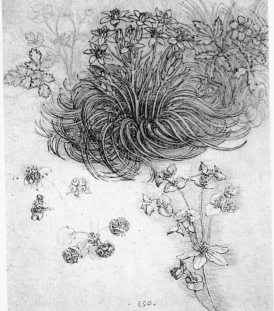

Star of Bethlehem (star anemone) and other plants, 1505–1508
Red chalk, pen and ink
19.8 x 16 cm
Windsor, Royal Library

The Last Supper

Thirteen men are seated at a table; they have started up from their meals in great distress with shock and indignation written on all their faces, their passionate gestures expressing their agitation. Christ alone remains calm in the middle of his distraught disciples. He is at once the cause and the object of all their questions and protestations. In the Bible it says: "Verily I say unto you, that one of you shall betray me. And they were exceeding sorrowful, and began every one of them to say unto him, Lord, is it I?" It is the moment of this announcement of betrayal that Leonardo has depicted; the occasion is the last meal that the disciples will take together before Christ is arrested and crucified. It is also the evening on which the Eucharist is observed for the first time: from now on,

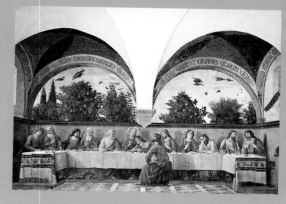

Domenico Ghirlandaio
The Last Supper, 1480
(detail)
Fresco
Florence, Chiesa di Ognisanti

bread and wine will be considered symbols of the body of Jesus. This is expressed in the painting by the outstretched arms of Christ, which focus the attention of the viewer on the bread and glass of wine in front of him. The *Last Supper* is still in the location for which it was originally created, the refectory of the monastery of Santa Maria delle Grazie in Milan. As with many other Tuscan monasteries, the idea was that the monks would be able to focus their attention on the last meal of their Lord during their own meal times. The picture was

donated and paid for by Ludovico il Moro, who had chosen the monastery to be the final resting place of his family; the coat of arms over the painting is a reference to his dynasty. The *Last Supper* covers an entire wall on the narrowest side of the refectory. At almost 9m wide it is the largest picture that Leonardo ever painted. The *Last Supper* represents the classic formulation of this biblical theme in the history of Western art and has never been surpassed. The tension and significance of the scene are narrated with unparalleled intensity; the full expressive power of Leonardo's composition is revealed if the picture is compared with Domenico

Study for the Last Supper, mathematical figures and calculations, ca. 1495–1497
(detail)
Pen and ink drawing
(facsimile), 26 x 21 cm
Florence, Gabinetto dei Disegno e delle Stampe

While those to the right of the Lord ... threaten direct revenge, to his left there is expressed the most heartfelt shock and revulsion at his betrayal. James the Greater reels back in horror, spreads his arms wide and stares down, his head bowed like one who thinks he has seen the monster ... with his own eyes.

Johann Wolfgang von Goethe

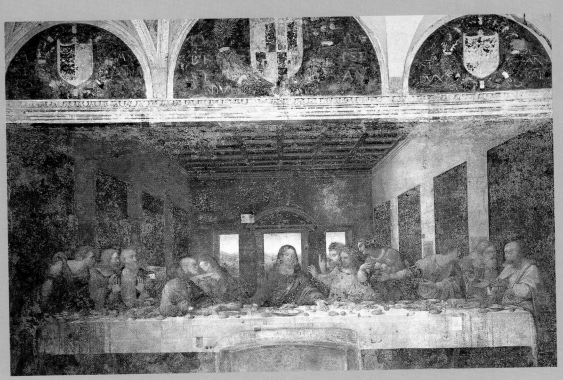

Ghirlandaio's *Last Supper*. The disciples are not arranged in static rows, but placed in groups of three to create tension, and linked with one another through their gestures. The bright landscape in the background acts as a halo to emphasize the central figure of Christ. Christ also functions as the center of the perspective structure, the point at which all the vanishing lines converge. Leonardo incorporated the figure of Judas for the first time into the group of disciples – he is pictured to the left of Christ – identifying him only by his gesture of reeling back in fear. The *Last Supper* was admired and copied even during Leonardo's lifetime. Later artists also created works that were a response to the painting, from Anton van Dyck and Rembrandt to Salvador Dali and Andy Warhol.

The Last Supper
1495–1497
Oil and tempera on masonry
422 x 904 cm
Milan, Santa Maria delle Grazie

Gestures and Faces – the Art of Expression

Leonardo's *Last Supper* is the result of a prolonged study and contemplation of the expressive nature of gestures and facial expressions. He wrote: "A good painter paints essentially two things: people and their inner condition. The first is easy, the second difficult, as it must be expressed through gestures and movements of the limbs. All this may be learned from deaf-mutes, for they do it better than anyone else."

In his *Last Supper*, Leonardo achieved these goals to perfection. Each of the twelve apostles is shown in an attitude that precisely reflects his emotional state. Goethe, who was a great admirer of Leonardo's *Last Supper*, thought that: "... this could only be done by an Italian. In his country, the entire body is animated by the soul, every limb takes part in expressing feelings, passions – indeed, even thoughts." In going beyond the traditional repertoire of gestures in painting – such as those of blessing, greeting, and worship – Leonardo sought new characteristic attitudes; body and face were to be universally comprehensible and naturally express the interior life of a person.

Exaggeration was to be avoided: "I recently saw an angel in a painting of the Annunciation that looked as if it wanted to chase the Madonna out

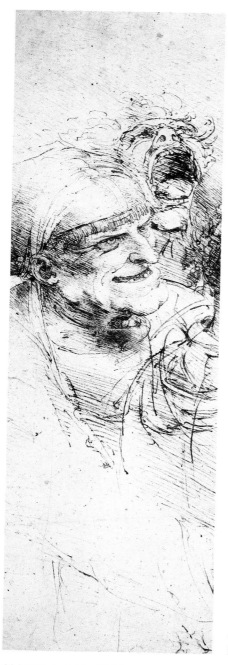

Grotesque heads, ca. 1490 (detail) Pen and ink drawing (facsimile) Florence, Gabinetto dei Disegni e delle Stampe

In his numerous studies of human physiology, Leonardo also made use of exaggeration. In this drawing he has intensified the features of the figures so that they appear grotesque. The artist was not concerned with achieving the comical effects of a caricature; instead he was rather testing the expressive boundaries of the human face. Leonardo was as interested in ugliness as much as he was in the ideals of beauty. Giorgio Vasari wrote that he was sometimes so fascinated by people with unusual faces or strange beards and hair-styles that he would be tempted to follow them about the entire day. His drawings of grotesque heads were published in the seventeenth century as copperplate engravings and were enormously popular with artists and collectors.

The Last Supper
1495–1497
(detail)
Oil and tempera on masonry
Milan, Santa Maria delle Grazie

The faces of Bartholomew, James, and Andrew to the left of the painting express indignation, tension, and dismay.

The Last Supper
1495–1497
(detail), Oil and tempera on masonry
Milan, Santa Maria delle Grazie

To the right of the picture, the elderly apostle Simon raises his hands beseechingly.

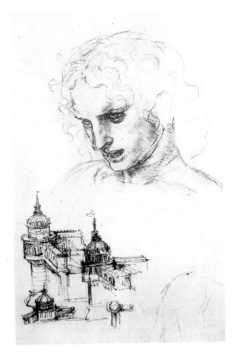

of the room, with movements which suggested abuse of the sort one might direct at a contemptible enemy, and the Madonna looked as if she wanted to throw herself from the window out of desperation."

In order to avoid such mistakes, Leonardo advised artists to observe people on the street and to record their movements in a sketch book. For the *Last Supper* Leonardo put together a list of motifs, some of which he later used in the painting: "A man spreads his hands out so that the palms are visible, and draws his shoulders up to his ears in a gesture of astonishment. Another man is speaking into his neighbor's ear, and the listener turns to him …;

yet another, who holds a knife, knocks a glass on the table over with his hand when he turns around."

Leonardo sought out particularly expressive people to use as models for the faces of the Apostles. Sometimes he found them in taverns or in hospitals; he even considered using a Milanese noble as the model for the head of Christ. On one occasion, he is supposed, in the course of a dispute, to have threatened to use the head of the prior of the monastery for which he was painting the *Last Supper* as a model for Judas.

Head of the apostle James the Greater and architectural studies (preparatory studies for the Last Supper),
ca. 1495–1498
Red chalk, pen, and ink on paper
25.2 x 17.2 cm
Windsor, Royal Library

This study of a model shows the same view of the head of James the Greater as it appears in the *Last Supper*. The expression on his face combines astonishment, fear, and a dark foreboding.

Art as Experiment – Painting Techniques and Restoration

He would often ... mount the scaffolding early in the morning, for the Last Supper was situated rather high above the floor, in order not to let his brush rest from dawn to dusk; but rather, without thought of food or drink, work without interruption.

Matteo Bandello, writer and contemporary of Leonardo's

When Giorgio Vasari saw the *Last Supper* in 1556 he was able to observe the deterioration that the mural had already undergone. In the centuries to come, complaints about the continued decline of the painting increased. Leonardo's painting technique was early on blamed for the irrevocable process of decay. In contrast to his contemporaries he did not work with the usual fresco technique, in which paint was directly applied to fresh, wet plaster. Instead, he developed a new method of mural painting in order to be able to work on a picture for a longer period – as he was accustomed to do from oil painting. According to conservators he used oil and tempera paints on a ground of resin and pitch. Leonardo spent his whole life inventing new artistic techniques, and improving traditional paint mixtures. During his apprenticeship with Andrea del Verrocchio, Leonardo experimented with oil painting, a technique new to Italy at the time. His notebooks contain recipes for priming coats, binding agents, and varnishes. The artist described how resin could

Right:
The Last Supper,
1495–1497
(detail, post-restoration)
Oil and tempera on masonry
Milan, Santa Maria delle Grazie

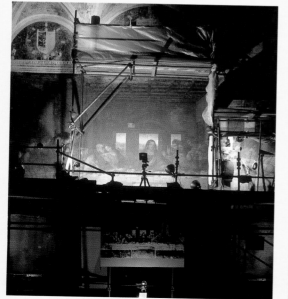

Left:
The Last Supper, Milan,
Santa Maria delle Grazie
Photo from 1982 showing
restoration work.

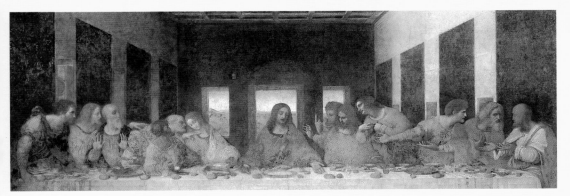

The Last Supper

1495–1497 (post-restoration
condition)
Oil and tempera on masonry
422 x 904 cm
Milan, Santa Maria delle
Grazie

be obtained from cypresses
or juniper bushes,
to produce a varnish
containing nut oil. He also
opened up new artistic
possibilities with his
discovery of pastel sticks,
which combined colored
pigments and wax.
Leonardo's attempts to
invent a feasible technique
of mural painting were not,

however, crowned with
success. Compared to
his comparatively well-
preserved oil paintings, his
murals – the Last Supper, the
decorative paintings in the
Sforza castle and The Battle
of Anghiari (page 60) – are
either in a desolate state or
have not survived. However,
there is a great deal of
evidence to indicate that it
was not Leonardo's
newfangled techniques
alone that contributed to
the destruction of the Last
Supper, but rather the
dampness of the wall
on which it is painted.
Negligent treatment,
flooding, and war damage
have all played their part
over the centuries. The paint
began to flake off, and mold
continually formed on the
surface. Over the past 250
years, the Last Supper has
been restored countless
times. New layers of paint
and conservation attempts
mean that large areas of the
painting have been
damaged. The most recent
restoration work took more
than 20 years and was
completed in early 1999.

Misleading touch-ups and
layers of dirt were removed
millimeter by millimeter in
order to expose Leonardo's
original once again and the
painting's colors now seem
much more vivid. Empty
spaces through which bare
masonry was exposed were
carefully touched up with
watercolors, which can
easily be removed.

Right and left:
The Last Supper,
1495–1497
(detail, pre-restoration
condition)
Oil and tempera on masonry
Milan, Santa Maria delle
Grazie

The Dream of Flight

You will test this device over a lake, and wear a tube fastened around your middle so that you will not drown should you crash.

Leonardo da Vinci

Model of a parachute
from plans by Leonardo da Vinci
Amboise, Le Clos Lucé

No other project preoccupied Leonardo as persistently as realizing the desire to fly. The idea of being able to lift off like a bird into the air was one of Man's oldest dreams. Mythology told of the flight of Icarus with his wings of wax and birds' feathers. Later ages, too, had a wealth of stories about flying men. In the thirteenth century the English philosopher Roger Bacon wrote about machines that were allegedly capable of flight. And Italian Renaissance engineers of the fifteenth and sixteenth centuries were also captivated by the utopian idea of manned flight. But it was not until the Mongolfier brothers launched their hot-air balloon in 1783 that these attempts were crowned with success. Leonardo da Vinci's first sketches of flying machines date back to his early creative period in Florence. Later in Milan he invested a great deal of time and energy in these projects. The more his knowledge of the physical laws of mass, force, and movement increased, the closer the solution to the problem seemed to him. His indefatigable imagination and will to experiment resulted in the most diverse designs for flying machines. Amongst these was a simple parachute which the pilot was to grasp with his hands, a glider with a horizontal sail, and more complicated pieces of equipment with movable wings which the pilot was to operate via an ingenious system of ropes and pulleys. Nature served Leonardo as a model in all his conceptualizations. He said: "The bird is an instrument which functions according to mathematical laws, and man is capable of making such an instrument with all these movements." To test the potential of his ideas he built small models from paper and wax. Referring to the model of his "helicopter" he said: "If this device is made well in a screw shape … and one can cause it to rotate quickly, it can be seen that the screw functions like a wing and can ascend to a great height."

Design for an artificial wing, 1493–1495
Black chalk, pen and ink
50 x 30 cm
Codex Atlanticus,
folio 313 r a
Milan, Biblioteca
Ambrosiana

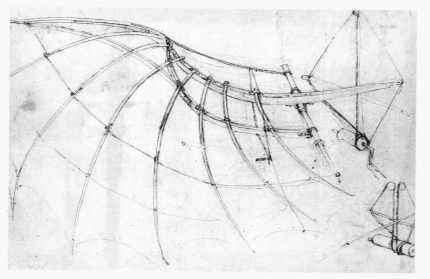

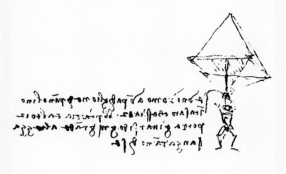

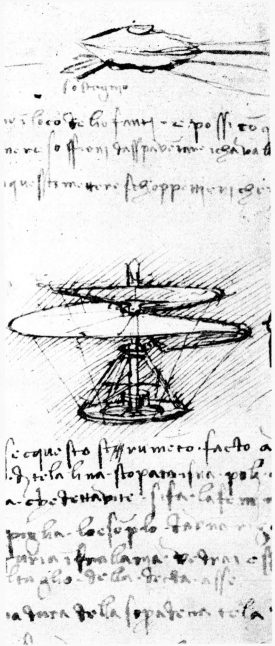

Drawing of a parachute,
ca. 1500
Drawing
30 x 50 cm
Codex Atlanticus, Folio 38 l v
Milan, Biblioteca
Ambrosiana

**Sketch of a helicopter/air
screw**, 1487–1490
(detail from a page of
sketches)
Drawing
Manuscript B, Folio 83 v
Paris, Institut de France

Insurmountable obstacles prevented this idea from being realized on a larger scale: in order to maintain the weight of a person as well as the heavy machine in the air, enormous wing spans would have been necessary. Leonardo would probably have succeeded in constructing a glider similar to a modern hang-glider if he had had access to modern lightweight materials instead of just wood, fabric, and leather. Whether Leonardo himself attempted to fly is not known. In any case he ultimately abandoned the experiments after his efforts failed to get off the ground. But he continued to study the flight of birds right to the end of his life. On the basis of his observations, he was able to draw the individual phases of the movements of a flying bird accurately. He depicted birds flying when there was wind and when it was still, he pondered the problems of balance in flight, and he developed ideas on the properties of air, air resistance, and lift that were not investigated scientifically until much later.

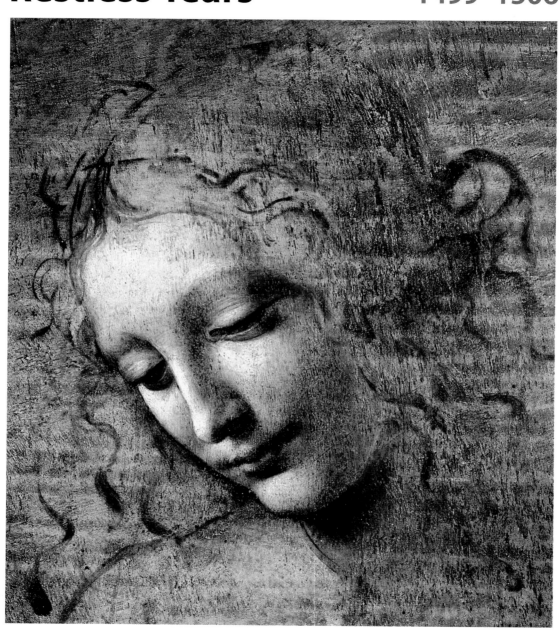

Leonardo's long stay in Milan in the service of Ludovico il Moro was abruptly brought to an end by the invasion of the French. In the search for new patrons he left Lombardy and traveled via Mantua and Venice to his home town of Florence. He began work on various paintings without completing any of them, and spent a lot of time undertaking mathematical studies. He then worked for ten months as an engineer for the military commander Cesare Borgia, and traveled in the soldier's sphere of influence in Tuscany and Umbria. Finally he returned to Florence, where he received a commission from the state to paint a mural in the Palazzo Vecchio, *The Battle of Anghiari*. In the years after 1500 he met two of the age's most important artists: Michelangelo became his fiercest rival, while the young Raphael from Urbino studied Leonardo's work, including the still incomplete *Mona Lisa*, with the greatest interest.

The first globe

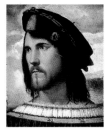

The commander Cesare Borgia

1500 The geographer Martin Behaim produces the first globe.

1502 Founding of the Persian Empire under Ismail I.

1504 The postal system is born: Franz von Taxis creates the first postal communication between various European courts.

1506 Pope Julius II lays the foundation stone for the new St. Peter's in Rome.

1499 In October, Leonardo's patron Ludovico il Moro is overthrown by the French. Leonardo leaves Milan accompanied by several pupils and stays at the Mantuan court.

1500 Leonardo travels on to Florence via Venice.

1501 Work on the design of *Virgin and Child with St. Anne.* Mathematical studies.

1502 Leonardo becomes Cesare Borgia's military engineer.

1503 Return to Florence. Commission for *The Battle of Anghiari* in the Palazzo Vecchio.

1504 Death of his father.

1505 Probably travels to Rome early in the year. Study of bird flight. Work on the portrait *Mona Lisa.*

Opposite:
La Scapagliata, ca. 1500
Umber and white lead on poplar wood
27.7 x 21 cm
Parma, Pinacoteca Nazionale

Right:
Neptune, 1503-1504
Chalk drawing, 25.1 x 39.2 cm
Windsor, Royal Library

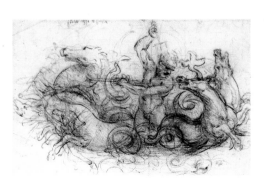

New Patrons and Benefactors

Leonardo always kept his distance from the political conflicts of his age. But when the French under Louis XII became actively involved in Italian politics and occupied Lombardy and its capital Milan in 1499, he had to reach an understanding with the new authorities. After Ludovico il Moro, his benefactor of many years, had fled, Leonardo contacted the French. Their soldiers may have wantonly destroyed his great clay model of the Sforza equestrian statue, but the French king was greatly impressed by Leonardo's painting, claiming that he would like to have taken the *Last Supper* back to France with him. The political situation in Milan remained uncertain, however, and in December 1499 Leonardo decided to leave the city. Accompanied by his pupils and his friend, the mathematician Lucia Pacioli, he traveled at first to Mantua.

There, at the court of Isabella d'Este, a sister-in-law of Ludovico il Moro, he could count on a warm

Plan of Imola, 1502
Watercolor, pen, and ink (facsimile)
44 x 60.2 cm
Vinci, Museo Vinciano

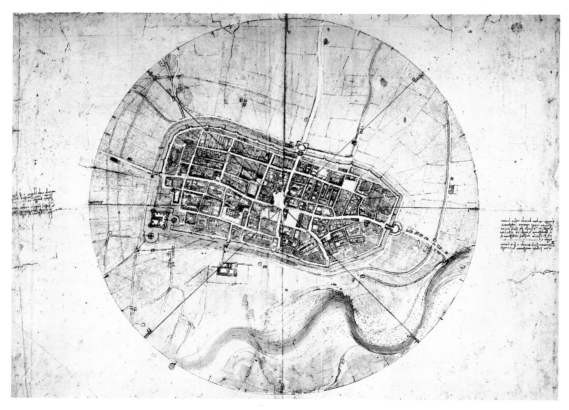

Portrait of Isabella d'Este, 1500
Black and red chalk on cardboard
46 x 36 cm
Paris, Musée du Louvre

Isabella d'Este was an educated lover of the arts and a patron who supported a number of artists.

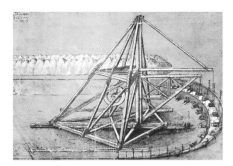

Dredging machine, ca. 1503
Chalk, pen, and ink on paper
40 x 22 cm
Codex Atlanticus I, Folio-v-b
Milan, Biblioteca Ambrosiana

Leonardo probably designed the dredging machine in spectacular plans to divert the river Arno. With the aid of machines, he planned to dig a canal which would run in a curve north of the river. As with many of his technical schemes, Leonardo intended to multiply the effect of human labor by using machinery. Digging work began in the summer of 1504 with 2000 workers, but the project had to be abandoned due to intractable difficulties.

reception. This cultivated princess held his painting in high esteem, and immediately had Leonardo make a portrait of her; Leonardo left Mantua for Venice almost as soon as he had sketched the cartoon for this picture. Nor did he stay long in Venice. He would certainly have met artist colleagues there such as the aging Giovanni Bellini or the young Giorgione (page 57). He also worked on plans for securing the eastern borders of the Venetian Republic against the impending attack of the Turks.

He had arrived in Florence by April 1500 at the latest. Political circumstances in the city had changed fundamentally during his absence. The Medici had been driven into exile in 1494, and a new Republican government now held power; amongst its leaders was State Secretary Nicoló Machia. Leonardo took rooms in a Florentine monastery and received a commission for an altarpiece of *The Virgin and Child with St. Anne*. But he often lacked the patience for painting. A contemporary remarked that Leonardo lived for the day, and would devote himself to studies of geometry.

Cesare Borgia's offer that Leonardo should enter his service as a military engineer may have come at just the right time. For ten months he traveled through central Italy in the entourage of this unscrupulous power politician, who was an illegitimate son of the pope. Leonardo inspected fortifications and drew maps such as that of Imola. Back in Florence he advised the city government on their plans to cut off the water supply to the hostile city of Pisa by redirecting the river Arno. When the project proved unfeasible, he developed new plans for a diversion of the Arno for peaceful purposes. But his intention of using the water for irrigation and energy generation was never put into practice.

Diversion of the river Arno, ca. 1503
Chalk and ink
35.5 x 48.2 cm
Windsor, Royal Library

This map of northern Tuscany shows the course of the canal planned by Leonardo to run above the Arno.

The Discovery of Landscape

A landscape is a piece of nature, a snapshot of man's environment, with mountains, rivers and valleys, trees, fields, and meadows. In the Middle Ages, landscape was seen, above all, as God's creation which, since Adam and Eve, had had to be cultivated with the sweat of one's brow. As a result depictions of landscape had only an inferior role to play in painting for a long time.

Rocks and trees were painted crudely and simplistically merely in order to allude to a background for a particular scene. During the Renaissance, people began to see nature and landscape with different eyes to those of their medieval forebears. The fifteenth century discovered the aesthetic charm of landscape; Leonardo formulated this in the following way: "What causes

you ... to leave your dwelling in the city, to depart from friends and relatives, and to wander over mountains and forests, and through the countryside, but the beauty of the natural world which you ... can only enjoy with your eyes." An early pen and ink drawing by Leonardo (page 9) is considered the first pure landscape in the history of Western art. It is not a picture of a real scene, but has been created at least partly from the artist's imagination. The German painter Albrecht Dürer (1471–1528) was the first artist to discover realistic landscapes. On his two trips to Italy, in 1495 and 1506, Dürer crossed the Alps and

Birch grove, 1498–1500
Drawing in red chalk (facsimile), 19.1 x 15.3 cm
Florence, Gabinetto dei Disegni e delle Stampe

Albrecht Dürer
Italian Mountains,
1494–1495
Watercolor
21 x 31.2 cm
Oxford, Ashmolean Museum

painted magnificent watercolors in which the alpine scenery is depicted with topographic precision. For centuries the pure landscape – one without action or human figures – had been the preserve of drawing, but from the fifteenth century background landscapes in religious pictures became increasingly naturalistic and vivid. Painters discovered atmospheric perspective as a way of providing a landscape picture with depth, by depicting objects in paler and bluer colors the further away they were. In pictures of the early Renaissance in

Florence, hills still often appeared like stage flats propped up behind one another. It was Leonardo who first succeeded in painting a unified, coherent and realistic depth of space. He combined all the pictorial elements – trees, water, mountains and sky – into a single atmospheric image such that the transition between objects in the foreground and the background is barely perceptible. The basis for this artistic achievement was Leonardo's own observations outdoors; he established, for example, that the human eye perceives objects as being less focused the further away they are. Leonardo did not conceive of nature as an unchanging, static collection of objects. He recognized that our view of the natural world is constantly influenced by light and shade, by the time of day, by weather and the seasons. In his notes to a treatise on painting he wrote:"The changing or fleeting properties of foliage are: shade, light, shine and transparency …" Or:"When one sees trees from the side where they are illuminated by the sun, they all seem almost equally bright; and the shadows in their interiors are hidden by the illuminated leaves which are interposed between one's eye and the shadow."These kinds of observations and some of his sketches are reminiscent of the Impressionist painters of the nineteenth century, who

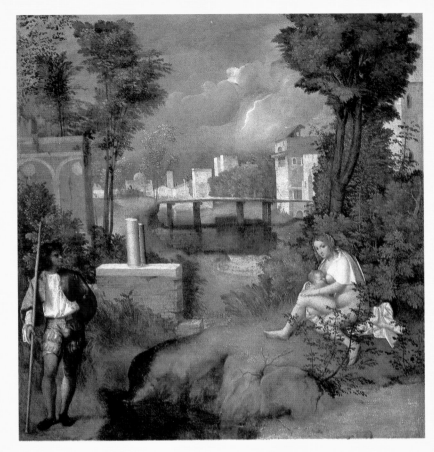

sought to capture the fleeting effects of light and color in their paintings. In Leonardo da Vinci's pictures the landscapes of the background are inseparable from the events depicted in the painting. A picture like the *Mona Lisa* (page 63) would be unthinkable without the softly focused landscape in the background. This ability of landscape painting to convey atmosphere was also discovered by the

Venetian painter Giorgione (ca. 1477/78–1510). His painting *The Thunderstorm* made landscape an independent subject of painting for the first time. The artist used color as the primary means of constructing the painting, and all the pictorial elements are interwoven with each other. Although the picture does not relate a simply readable story – and is still difficult to interpret even today – the dreamy,

Giorgione
**The Thunderstorm
(La Tempesta)**, ca. 1506
Oil on canvas
82 x 73 cm
Venice, Galleria
dell'Accademia

poetic charm of the landscape exerts a strong effect on the viewer.

Rival Artists: Florence Around 1500

Between 1503 and 1506 two of the greatest geniuses of the Renaissance met in Florence for the first time – Leonardo da Vinci and Michelangelo Buonarroti. Leonardo was already over 50 years old and could look back on a successful career, while the young Michelangelo was just

Above:
Palazzo Vecchio
built 1299–1382
Florence, photo

Left:
Michelangelo
David, 1501–1504
Marble statue
height 434 cm
Florence, Galleria
dell'Accademia

Michelangelo's
David was the first
free-standing
monumental
sculpture to be made
since Classical times.
The figure is felt to be
the perfect expression
of the Renaissance
conception of Man:
bold, strong, and
conforming to the
ideals of beauty. A
commission of artists,
including Leonardo,
decided to place
David in front of the
Palazzo Vecchio as a
symbol of the free
Republic of Florence.

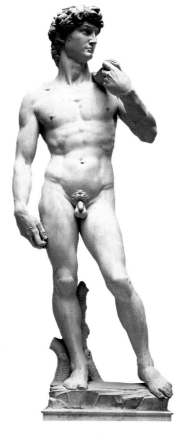

beginning to make a name for himself with his first large works of art. Michelangelo had finished his apprenticeship in Florence, and after a period in Rome had returned to this city on the river Arno in 1501. When, a short while later, the 21-year-old Raphael from Urbino arrived in Florence, it meant that the three figures whose work brought about the change to the High Renaissance style were all briefly in Florence together. Their views on art, as well as their personalities, could not have been more different.

Raphael, the youngest of the three, received important lessons for his own artistic development from both Michelangelo and Leonardo, and his gentle nature meant that he was never the cause of any conflict. But tensions quickly arose between the two older men. At the time of the Renaissance, it was thought that a certain degree of competition between artists was simply part of the profession: only by competing

Right:
Aristotile or Bastiano da Sangallo
Copy of Michelangelo Buonarroti's cartoon for the *Battle of Cascina*, ca. 1542
Grisaille on canvas
Wells-next-the-Sea, Holkham Hall, Collection of the Earl of Leicester

This copy is all that has survived of Michelangelo's design for the *Battle of Cascina*. The mural planned for the Palazzo Vecchio was never completed. The scene shows Florentine soldiers surprised by the enemy while bathing in the Arno. Contemporaries were especially impressed by the artist's perfect depiction of naked men in a variety of poses.

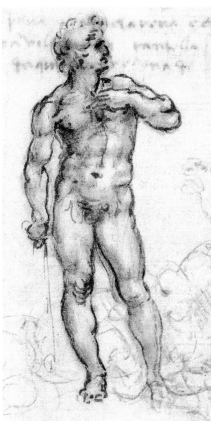

Study of a male nude, ca. 1504
(extract from a study page)
Black chalk, pen, and ink
Windsor, Royal Library

During his time in Florence, Leonardo was impressed by Michelangelo's heroic, muscular male nudes. He rejected, however, an emphasis on musculature which would only show the human body to look "like a sack of nuts". In this sketch he has captured Michelangelo's *David* relatively accurately but has given the figure more solid proportions.

with each other would artists be challenged to produce their very best.

The biographer Vasari wrote that Michelangelo and Leonardo even had violent arguments in the street. While Michelangelo saw sculpture as the highest of all the arts, Leonardo expressed a more contemptuous opinion in his writings: it was "purely mechanical work which frequently causes [the sculptor] to sweat ... his face becomes smeared and covered with marble dust, so that he looks like a baker ..."

In 1503 the two artists became direct rivals when the Florentine government decided to have the great Council Chamber in the Palazzo Vecchio decorated with murals by Leonardo and Michelangelo depicting events in the history of the city. Neither Leonardo's *Battle of Anghiari* nor Michelangelo's *Battle of Cascina* was ever finished, as the artists were prevented from completing their work by other commitments.

The Battle of Anghiari

On Friday, June 5 1505, Leonardo noted: "… at the stroke of 1 in the afternoon I began to paint in the palace. Just at the moment of putting the brush to the wall there was a dreadful storm … The cartoon came loose, the water poured down, and the vessel carrying it broke. The weather worsened still more and a very great rain came down till nightfall …" By this time Leonardo had worked for two years on his designs for the *Battle of Anghiari*, and had begun to paint the wall of the great Council Chamber in the Palazzo Vecchio. As with the *Last Supper*, he experimented with an unusual technique, a type of encaustic with a binding agent containing wax that he had read about in the works of the Classical writer Pliny. Unfortunately, only preparatory drawings and partial copies have remained of the mural.

The theme of the painting was the victory of the Florentine mercenary army over Milan at Anghiari near Arezzo in 1441. Leonardo did not portray the historical events exactly as they occurred, but instead made a generalized picture of a battle. The *Battle of Anghiari* was part of a tradition of heroic depictions of cavalry battles that stretched back to antiquity. Famous examples in the early Renaissance painting of Florence were provided by Paolo Uccello's battle paintings for the

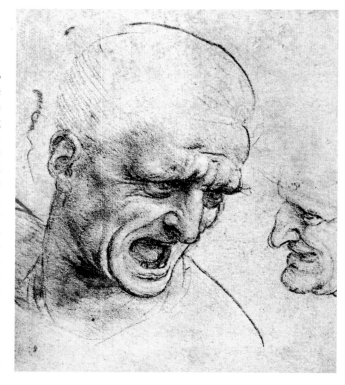

Medici. The *Battle of Anghiari* differed from its predecessors in its greater dynamism and intensity of expression. The bodies of the soldiers and their horses are intertwined in a tight space as they are locked in a bitter contest for their opponents' standards. The energy of the picture is pushed to an extreme by concentrating the power of the composition's movements in the center of the figurative group. From Leonardo's sketches we know that other groups of riders were to be added to the sides of the central scene to round out the composition. Leonardo had only completed a

Face study for the Battle of Anghiari,
ca. 1503–1504
Chalk drawing
(facsimile)
21.7 x 11.9 cm
Florence, Gabinetto
dei Disegni e delle
Stampe

Leonardo called war a "highly bestial form of insanity". In his studies for the *Battle of Anghiari* he showed the emotion of the soldiers in the contorted features of their faces.

The Battle of Anghiari (Tavola Doria), 1503–1505
Oil on poplar wood
85 x 115 cm
Munich, G. Hoffmann Collection

It is still a matter for debate whether this oil sketch is by Leonardo himself, or whether it was made after his incomplete mural. In spite of the work's fragmentary character, the extraordinary quality of the design is clear. The compact composition seems about to fly apart under the force of its internal dynamism.

small portion of the mural when he abandoned the work in 1506 and left for Milan. The rest of the unfinished painting disappeared 50 years later when the Council Chamber was redecorated. One of the artist's texts conveys his thoughts on battle paintings: "Dust should mix with the blood and become red mud; ... Others should grind their teeth in their death agonies, roll their eyes, press their fists against their bodies and thrash about with their legs ... and the churned up earth should show the footprints of men and the hoof prints of horses ..."

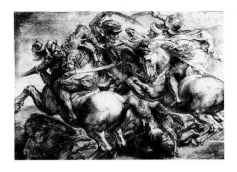

Peter Paul Rubens
Cartoon from Leonardo's *Battle of Anghiari*, ca. 1603
Black chalk, silver point, and watercolor
45.2 x 63.7 cm
Paris, Musée du Louvre

A good impression of Leonardo's *Battle of Anghiari* is conveyed by Rubens' drawing on the same theme. His paintings are almost inconceivable without Leonardo's example.

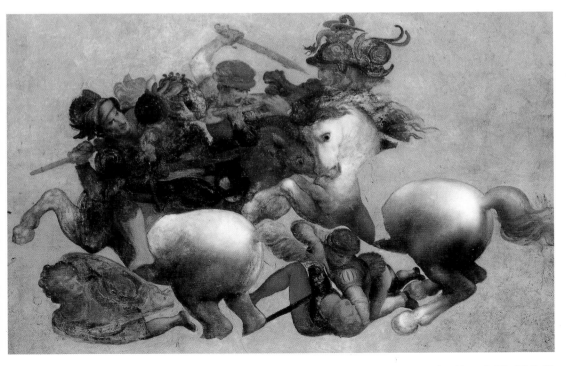

Mona Lisa

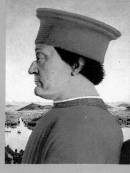

The *Mona Lisa* should really be called *Portrait of a Lady*. Even today it is not clear who Leonardo actually depicted. The title used today originated with Giorgio Vasar, who claimed that Leonardo had portrayed the wife of the Florentine merchant Francesco del Giocondo. In much of the world her first name is conventionally used as the picture's title, while the Italians call the painting

La Gioconda. Leonardo may have received the contract around 1503 when Lisa was 24 years old. According to other sources it was painted for Giuliano de Medici and shows a "certain lady", possibly a courtesan. At first the composition appears simple and rather straightforward. The woman is seated on an armchair in front of a wide landscape. Behind her can be seen the balustrade of an open

Piero della Francesca
Portrait of Battista Sforza, ca. 1465
(detail)
Tempera on wood
Florence, Galleria degli Uffizi

Piero della Francesca
Portrait of Federico da Montefeltro, ca. 1465
(detail)
Tempera on wood
Florence, Galleria degli Uffizi

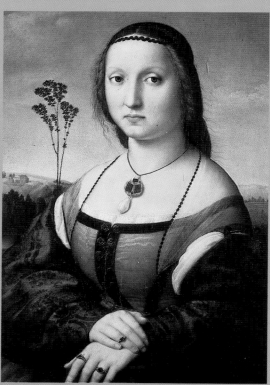

loggia. Two columns at the sides were removed when the picture was reduced in size. In contrast with other portraits of the time, it is not merely the subject's face and shoulders that can be seen. Her posture has been carefully arranged: she fixes the viewer with her gaze but turns her upper body to one side. This makes the figure seem almost alive and the composition appear harmonious. Her hands, which are pictured resting on each other, lend the picture a compactness and convey an impression of calm dignity. The proverbial smile of the *Mona Lisa* is barely hinted at: a slight

Raphael
Portrait of Maddalena Doni, ca. 1505
Oil on wood
63 x 44 cm
Florence, Palazzo Pitti

shadow plays about her eyes and the corners of her mouth. She may at first appear to the viewer to be smiling and then just as quickly seem serious and unapproachable. A subtle, barely noticeable fuzziness, the so-called *sfumato* (page 76), was used by Leonardo to create a vague impression of movement and so avoid the stiffness and awkwardness that many portraits possess. This trademark of Leonardo's paintings stands out if they are compared with the precise portraits of Piero della Francesca. Nothing in Leonardo's picture appears really tangible, nothing is fixed or motionless. Even the shapes in the landscape seem to sway gently and flow into each other. Tonally both the figure and the landscape are perfectly harmonized. There is no ornamentation, no outward

… it seemed to him that she was submerged in the mysterious landscape behind her as if into a veil of still, green water. "

Georg Heym, Expressionist Poet (1887–1912)

gloss to distract the gaze from the expression of inner vitality which is the real theme of the picture. In his work on this picture, which took several years, Leonardo may have moved ever further away from his original intention of painting a realistic portrait, so that it gradually became an idealized representation and a thoroughly independent work of art. Leonardo never delivered the painting to the client and always kept it with him. Raphael must have seen the painting in Leonardo's studio before it was completed. His *Portrait of Maddalena Doni* shows the sitter in the same posture as the *Mona Lisa*. Raphael reproduced neither the vague smile, the misty landscape nor the dark tones of Leonardo's work; for all their similarities there are worlds between the mysterious magic of the *Mona Lisa* and the clarity of Raphael's picture.

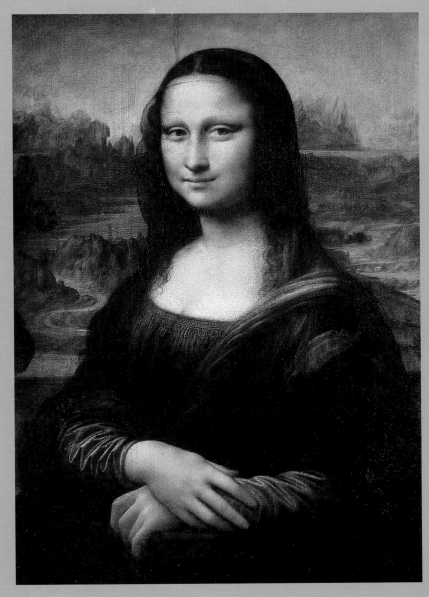

Mona Lisa (La Gioconda),
1503–1506
Oil on wood
77 x 53 cm
Paris, Musée du Louvre

The Myth of the Mona Lisa

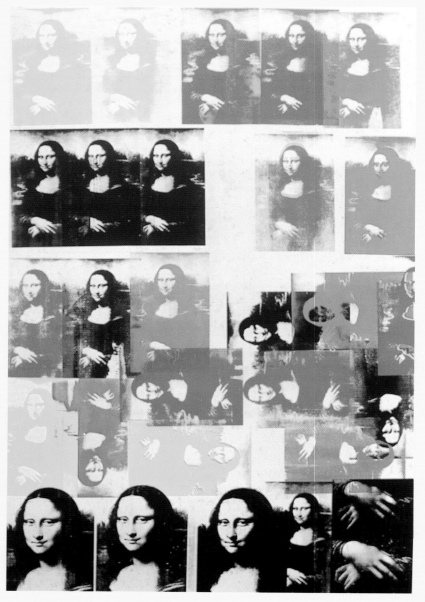

The *Mona Lisa* is the best known of Leonardo da Vinci's paintings, and probably the most famous work of art in the world. Everyone knows it, be it from the original in the Louvre or through one of the countless reproductions in books, or on postcards, advertisements, and T-shirts. The *Mona Lisa* has frequently been imitated, copied, modified and even, in the art of the twentieth century, caricatured and decontextualized. The *Mona Lisa* has inspired writers like no other art work, and it has challenged art historians to come up with ever newer interpretations.

The public's view of the painting has however changed over the centuries. Up until the seventeenth century, the *Mona Lisa* was considered above all a splendid and especially realistic masterpiece of portrait painting. The painting's composition was incorporated into the work of countless artists. It was not until the nineteenth century, however, that a *Mona Lisa* myth first emerged which was closely linked with a cult of genius

Andy Warhol
Mona Lisa, 1963
(detail)
Screen print on acrylic on underpainted canvas
320 x 208.5 cm
Private collection

surrounding Leonardo. The *Mona Lisa* became the very embodiment of the eternal female: she was by turns virtue personified and a femme fatale who bewitched the viewer with the smile of a sphinx only to reject him coldly.

The *Mona Lisa* cult reached a temporary peak in 1911 when the painting was stolen from the Louvre by an Italian worker. The theft and the spectacular rediscovery of the painting made headlines all around the world. But the growing reputation of the painting caused a backlash amongst twentieth-century avant-garde artists; the *Mona Lisa* became a symbol of dusty, traditional museum art which was violently opposed by the Dadaists and Surrealists.

The French artist Marcel Duchamp drew a beard and mustache on a cheap color copy of the painting, under which he wrote the letters LHOOQ, which, when pronounced in French, produce the obscene comment: "Elle a chaud au cul" – "She's got a hot ass." Looking back later,

Fernando Botero
Mona Lisa, 1978
Oil on canvas
187 x 166 cm
New York, Marlborough Gallery

Duchamp commented: "What is strange about this mustache and beard is that if you look at them the *Mona Lisa* does become a man." Fernand Léger painted her together with a sardine tin and a key ring to create the greatest possible contrast. But instead of destroying the aura of the picture, such attacks only increased its renown. The Colombian painter Fernando Botero, who transformed many famous paintings into the full-bodied formal language of his own work, has said: "The *Mona Lisa* is so popular, that she is perhaps no longer art. She is like a film star or a football player."

As with much of his work, the American pop artist Andy Warhol made the incessant reproduction of the painting itself the subject of his *Mona Lisa* adaptations. His screen prints show how the uniqueness of the original has been swamped by a flood of reproductions. Today, an unprejudiced view of the work is no longer possible; the picture threatens to degenerate into a cliché, its magic wearing off like a song heard once too often.

Right:
Marcel Duchamp
L.H.O.O.Q., 1919
Watercolor on a color print
19.7 x 12.4 cm
Philadelphia, Museum of Art

Left:
Fernand Léger
Mona Lisa with Keys, 1930
Oil on canvas
91 x 72 cm
Biot, Musée Fernand Léger

At the urging of the French king Louis XII, the Florentine government allowed Leonardo to move to Milan, although he was still far from finishing the *Battle of Anghiari* in the Palazzo Vecchio. In Milan, which was ruled by the French governor Charles d'Amboise, a number of commissions awaited the artist. Unfortunately, only one important painting from this period has survived, the *Virgin and Child and St. Anne*, which Leonardo worked on for some time. He returned to Florence frequently, in order to settle disputes about a family legacy with his half-brothers. During this period, Leonardo was intensively engaged in anatomical research and dissected corpses in a Florentine hospital. The riddles of the human body – and life in general – came to fascinate him more and more.

Opposite:
Anatomical drawing: fetus in the womb,
1510–1512
Pen drawing in brown ink with wash
30.4 x 22 cm
Windsor, Royal Library

Right:
School of Leonardo
Bust of Flora,
16th century
Wax sculpture
Height 67.5 cm
Berlin, Staatliche Museen zu Berlin, Preußischer Kulturbesitz, Sculpture Gallery

First pocket watch, dating from 1510

Francesco Melzi, a friend of Leonardo

1508 The German geographer Martin Waltseemüller calls the New World America for the first time, after the sailor Amerigo Vespucci.

1509 Henry VIII ascends to the English throne and initiates far-reaching reforms during his regency.

1510 Production of the first pocket watch, which had only one hand, by Peter Henlein.

1511 Maximilian I, ruler of the German Empire, considers becoming pope himself – a plan that was never realized. Portuguese explorers occupy the coast of Malaya and thus secure a Portuguese monopoly in the spice trade.

1506 At the end of May, Leonardo enters French-occupied Milan.

1507 Leonardo spends the winter with the Florentine Piero di Braccio Martelli, in whose house sculptor Gian-francesco Rustici also lives.

1508 Returns to Milan.

1510–11 Begins working with the anatomist Marcantonio della Torre. Works on the painting *Virgin and Child and St. Anne*.

1511 Death in March of the French governor of Milan, Charles d'Amboise. Leonardo works on designs for an equestrian monument to Marshal Gian Giacomo Trivulzio.

1512 The French are driven out of Milan. Leonardo is left without work and spends much of his time on the estate of his friend Melzi, close to the city.

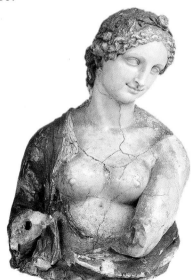

In the Service of the French King

Leonardo had probably already met the French king Louis XII in 1499 when French troops marched into Milan, to overthrow the Sforza dynasty. At that time, however, he does not appear to have received any commissions for artworks, and he left Milan for Florence. In May 1506 he did not hesitate to accept the invitation of the French governor of Milan, Charles d'Amboise, to return to the city. The chance to leave Florence was probably not altogether untimely because technical problems had developed with his work on the

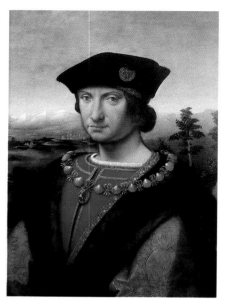

Andrea Solario
Charles d'Amboise,
ca. 1500
Oil on wood
75 x 52 cm
Paris, Musée du Louvre

Charles d'Amboise, the governor of the French king in Milan, was Leonardo's client and conveyed commissions to him from the king during the painter's second period in the city. This portrait is by Solario, a prominent artist in the School of Leonardo in Milan.

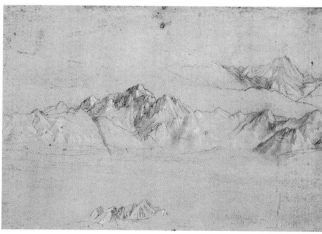

The Alps, ca. 1513
Drawing in red chalk
10.5 x 16 cm
Windsor, Royal Library

Leonardo's drawings and texts show his fascination for mountains. In an

analogy with the structure of the human body, he called rocks the "bones of the earth." On journeys into the mountains he examined fossils and

observed changes in light and atmosphere – studies which formed the basis of his landscapes.

mural of the *Battle of Anghiari* in the Palazzo Vecchio. Initially his stay in Milan was to have been limited to three months, as the Florentine government were impatient to have the painting finished: Leonardo had not "behaved towards the Republic as he should have; he has accepted a large sum of money but only started a small part of the work he was obliged to execute and he has been tardy in completing it." It was not for this reason, however, that the artist returned to Florence shortly after, but to settle disputes about a family inheritance.

Few clues remain as to the work he undertook during his second stay in Milan. In a letter Leonardo mentions that he had almost completed two pictures of the Madonna for the French king. Louis XII greatly

admired his painting and had commented to a Florentine envoy: "He is a capable master, and I would like to own several things by his hand … Certain small panels of the Madonna and various things according to my wishes, and I shall perhaps have him paint my own portrait." When King Louis XII entered Milan in May 1507, Leonardo was responsible for the artistic direction of the festivities. He was famous for his technical whimsies on such occasions, and once constructed a mechanical lion for the French king, which was able to walk a few paces before its chest opened to reveal a cavity filled with lilies.

As *peintre et ingenieur ordinaire* Leonardo received a generous salary, and he provided general artistic and technical advice as he had under Ludovico Sforza's government. The governor's commissions also left him enough time to pursue his own interests. It was now natural phenomena such as the anatomy of the human body or geology that interested him more than technical issues. Indications can be found in his notes that he undertook numerous trips for research purposes. He investigated, for example, alpine rocks and discovered fossilized mollusks far from the coast; he concluded that the land must once have been covered by ocean.

An important event in Leonardo's private life during these years was his encounter with Francesco Melzi (1493–ca. 1570), a young nobleman whose parents owned an estate not far from Milan. Melzi entered Leonardo's studio as a pupil where he showed talent, and became a close friend of the painter.

Astronomical observations, ca. 1507 (detail)
Drawing
Codex Hammer
Seattle, Bill Gates Collection

Leonardo's scientific endeavors were wide-ranging. In his observations his written notes are complemented by diagrams of his research.

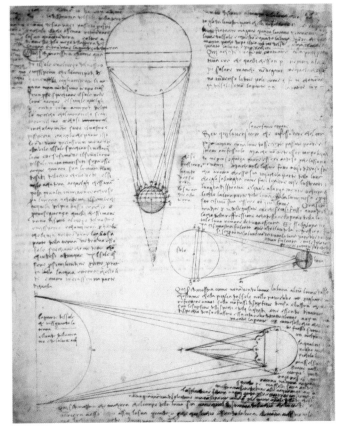

The Human Body

Leonardo's interest in human anatomy came from the studies he made for his paintings. In order to depict the movements of the human body as perfectly and realistically as possible, he thought it insufficient to draw studies of nudes, because this would reveal only the outside; he wished to understand the inner structure of the body as well and how bones, muscles, and sinews functioned together. Over time his interest in anatomy became an independent branch of research to which he devoted a great deal of attention. He conceived of the human organism as a wonderfully constructed machine, the principles of whose functions he sought to comprehend. The writings of the Classical physician, Galen, which formed the basis for contemporary medicine, were only partly able to satisfy his curiosity. He set out instead to explore a wide range of questions: "Describe: whence come catarrh – tears – sneezes – yawns … – insanity – sleep – hunger – pleasure – rage, where it affects the body – and likewise fear – fever – where sickness comes from … Describe, … how nourishment is transformed in the arteries – where drunkenness comes from – where dreams …" In the 1480s he had drawn extremely subtle and precise anatomical studies such as that of a skull. In the years after 1506 he worked together with the anatomy professor Marcantonio della Torre. But the dissection of corpses did not come easily to Leonardo; he wrote: "And if you should have a love for such things, you might be deterred by loathing, or if this did not sufficiently deter you, you might be restrained by fear of the living through the night hours in the company of these corpses, quartered

Anatomical drawing: section of a human skull, ca. 1489
Pen and ink
19 x 13.7 cm
Windsor, Royal Library

and flayed and horrible to behold, and if that does not discourage you, then perhaps you will have no talent for drawing …"

A certain amount of medical knowledge was also an absolute precondition: "But you may expect that this sight will not satisfy you because of the greatest confusion which arises from the mixture of membranes which are all mingled with

Left:
Anatomical drawing: shoulder studies, ca. 1510
Pen and ink with wash on black chalk
29.2 x 19.8 cm
Windsor, Royal Library

Right:
Anatomical drawing: skeleton studies, ca. 1510
Pen and ink with wash
28.8 x 20 cm
Windsor, Royal Library

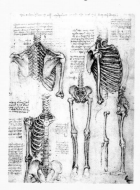

veins, arteries, nerves, tendons, muscles, bones, and blood." By drawing, Leonardo was able to form a clear picture of what he saw. His cross-sections, details, and views from various angles captured the particulars of anatomy. In spite of occasional errors in detail, his drawings are of an astonishing clarity. He was especially interested in the question of how life began. He did not dissect a human corpse for his famous *Drawing of a fetus in the womb* (page 66); instead he transferred to the human body knowledge he had gained from dissecting pregnant cows. When the pope forbade Leonardo from dissecting human bodies he used ox hearts to continue his studies of the circulatory system. There were few people alive in Leonardo's day who could rival his knowledge of the human body.

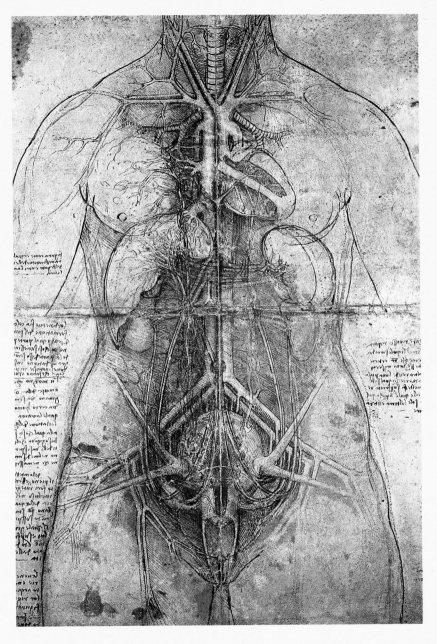

Anatomical drawing: dissection of the most important organs and the arterial system of a female torso, ca. 1507
Pen and ink over black chalk on brown paper
47.6 x 33.2 cm
Windsor, Royal Library

Sculpture

Leonardo never worked in marble as Michelangelo did; to attack a massive block of stone – the sort of work which Michelangelo so loved – was contrary to his artistic nature. Painting was always the highest artistic form for Leonardo. When he did engage in sculpture, he preferred light materials like clay, wax or bronze with which a figure could be modeled in stages. None of his large sculptural projects were ever carried out, and of those small sculptures that have survived, none can be attributed to him with any certainty. On the basis of sketches, documents, and the work of others in his circle, however, an impression can be formed of his sculptural activity. He would certainly have received a thorough training in the workshop of his master, Andrea del Verrocchio, an artist who was as comfortable with painting as he was with

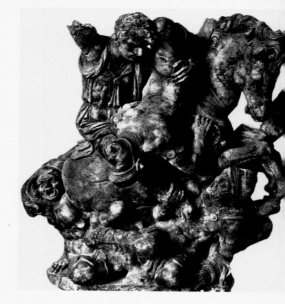

sculpture. According to Vasari, Leonardo modeled the heads of laughing children and women in his youth. These sculptures may have been intended as models for paintings; a number of Renaissance painters used three-dimensional figures or plaster casts as aids in painting in order to study the effects of light and shade, proportions and posture without having to resort to a live model. In his notes on the *Battle of Anghiari* (page 60), Leonardo himself mentioned small wax figurines used to depict

Studies for the Trivulzio Monument, ca. 1508–1511 (facsimile)
Pen and brown watercolor on coarse, gray paper
28 x 19.5 cm
Windsor, Royal Library

Gian Francesco Rustici
Equestrian group, 1495
Terracotta sculpture
Florence, Museo Nazionale del Bargello

the horses and their riders in the painting. A terracotta statuette in the Budapest Museum provides an idea of how these figures might have looked; it may even have been made by Leonardo himself. The powerfully modeled movements of the horse as it rears up recall his designs for equestrian monuments.

In addition, a number of small sculptural groups have survived from the studio of the Florentine sculptor Gian Francesco Rustici which may be connected with the *Battle of Anghiari*. This is all the more likely as Leonardo stayed in the same house as Rustici in Florence in the winter of 1507, and advised him on his large bronze

statue of John the Baptist for the Florentine baptistery. Shortly after in Milan Leonardo received a commission from Marshal Gian Giacomo Trivulzio to make a monumental equestrian statue for his tomb. For Leonardo this represented a welcome opportunity to resurrect the ideas for an equestrian statue that he had developed years earlier for the ill-fated *Sforza Monument* (pages 30-1). Whereas the Sforza statue was to stand in the open air, the Trivulzio Monument was planned for the interior of a chapel and was therefore to be life-sized. Leonardo sketched various alternatives, which featured a sophisticated architectural pedestal. Detailed costings for the work reveal that the final design was to involve numerous additional sculptures and reliefs. But Trivulzio was toppled from power when Milan fell to Allessandro Sforza in 1512, and all thought of making the monument was abandoned. On three occasions in his life Leonardo planned an equestrian statue: for Ludovico Sforza, for Gian Giacomo Trivulzio and probably once again toward the end of his life for the French king, François I.

School of Leonardo
Equestrian statuette, 1506–1508, Terracotta sculpture, 23.5 cm high Budapest, Museum of Fine Arts

Each of these extremely ambitious projects floundered on technical difficulties. Leonardo's designs were distinguished not only by the perfection of the horse, which was considered the noblest of beasts, but in particular by the dynamic conception of the mounted group. It was not until the Baroque era that similar designs were in fact made.

A female bust made from wax depicting Flora, Roman goddess of flowers and plants (page 67), is one of the most hotly debated sculptures from the circle around Leonardo. The smiling figure shows a strong resemblance to several of the female figures in his paintings. While some scholars claim that it is either a heavily restored original or a work from the same era, others maintain that it is a commercial forgery from the nineteenth century.

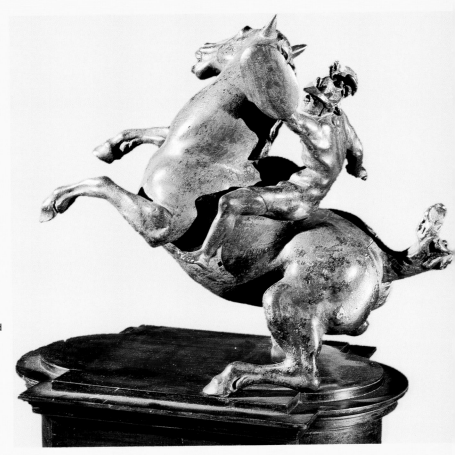

The Virgin and Child and St. Anne

Masaccio
Virgin and Child and St. Anne, 1420–1425
Tempera on canvas
175 x 103 cm
Florence, Galleria degli Uffizi

Masaccio arranged the frontal views of these figures in a series in the manner of Byzantine icons.

Cartoon for Virgin and Child and St. Anne, ca. 1499
Charcoal and chalk on cardboard
141.5 x 104.6 cm
London, National Gallery

The composition of the figures seems more static in this version than in the later painting. The heads of St. Anne and the Virgin are almost at the same height. Instead of the lamb symbolizing the Passion of Christ, John the Baptist, a reference to Christ's baptism, appears as a child.

As is so often the case with Leonardo's work, the sources for the *Virgin and Child and St. Anne* are rare and, what is more, contradictory: had the artist already received the commission from the French king in 1499 after Milan had been occupied? Or was the picture begun later in Florence as an altarpiece for the Servite monks of SS. Annunziata? We do know that Leonardo worked on the theme for a long time, and developed several versions of the design. The last version was made during his second Milanese period from 1506, probably as a commission for the French king Louis XII, but even in his last years Leonardo was still working on studies for the Virgin's robe. Leonardo's designs for the *Virgin and Child and St. Anne* aroused the interest of the public almost as soon as the first cartoon was drawn. Vasari relates that "for two days men and women, young and old, made a pilgrimage to the room, as if to a magnificent festival, to admire this extraordinary work of Leonardo's which was astonishing the people."

The title of the picture – in Italian *S. Anna Metterza* – refers to the three generations depicted in the painting: St. Anne, her daughter Mary, and the Christ child. Anne therefore symbolizes the Christian church, while Mary is the embodiment of maternal love. She leans forwards to draw her son away from the lamb he is playing with, which symbolizes the Passion and Crucifixion of Christ.

The picture is remarkable for the youthful appearance of both women who look more like sisters than mother and daughter. The psychoanalyst Sigmund Freud suggested an interesting interpretation for this: Anne and Mary embody Leonardo's childhood memories of his two mothers, his biological mother and his stepmother.

It may indeed be that the smile of his mother, which he lost at such an early age, has been rendered in the features of many of Leonardo's images of women.

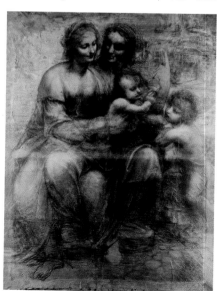

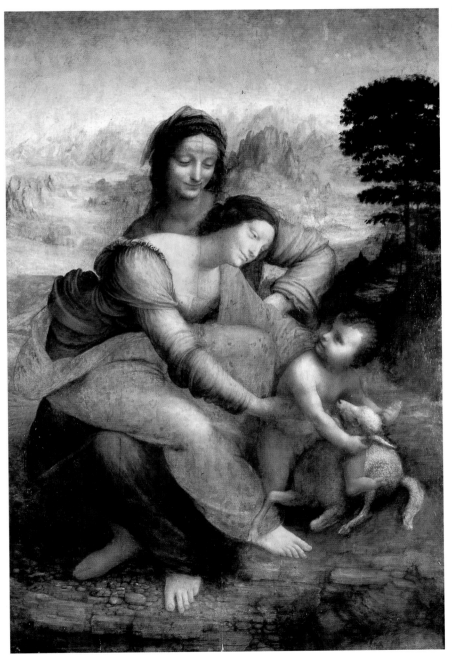

The Virgin and Child and St. Anne,
1506–1513
Oil on wood
168 x 130 cm
Paris, Musée du Louvre

In contrast with his earlier version of this theme, Leonardo fundamentally rearranged the figures, placing a greater emphasis on the landscape. The composition is now defined by a rhythmic succession of interlocking movements. Gestures and looks bind the figures together like links in a chain. Extending from the tranquil figure of St. Anne, a diagonal axis of movement develops, made up of gently curving forms. In spite of the meticulously composed posture of the figures, the group appears natural and relaxed. An unusual innovation was Leonardo's dynamic conception, penetrating the pictorial space, which he developed instead of the traditional seated motif. The composition was later echoed in numerous other paintings including those of Raphael, Michelangelo, and Andrea del Sarto.

Sfumato

Leonardo's *sfumato* is essentially a technique for painting what one cannot see: the air between objects. The Italian word "sfumato" can be translated as "vaporous, hazy, misty". It refers to a feature of Leonardo's paintings that is difficult to put into words, although it is immediately apparent to the eye. It is even more difficult to describe how he achieved this effect. Italian writers on art in the Renaissance used the word *sfumare* to describe an especially soft, almost imperceptible gradation of tone and shade in a painting. In his notes on the art of painting, Leonardo

himself remarked that light and shade should merge into each other without any visible transition, as if a fine veil of mist was shrouding the objects. The process reached its perfection in his painting of the *Virgin and Child and St. Anne*. There are no hard edges, no abrupt transitions or stark contrasts. Soft shadows float over the figures' faces, causing them to take on an exceptionally delicate quality.

The forms appear plastic, never rigid. The effect of *sfumato* can also be seen in the landscape. The rocky serrations of the mountain range appear as if out of a misty haze, are combined

Above:
Effects of light on a male profile, 1487–1490 (detail)
Drawing (facsimile)
Florence, Gabinetto dei Disegni e delle Stampe

Below:
The Annunciation, ca. 1470–1473, (detail)
Oil and tempera on wood
Florence, Galleria degli Uffizi (complete picture on page 15)

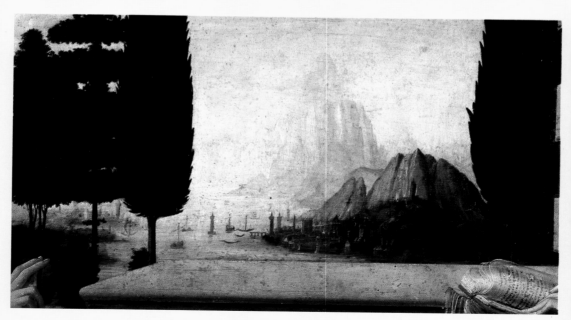

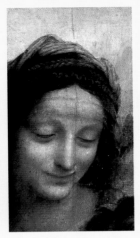

with the water and then merged into the color of the sky. Leonardo da Vinci wrote: "I maintain that the blue of the air is not its own color but that this is caused by a warm, hazy moisture composed of excessively fine and invisible particles; this moisture captures the rays of the sun … Everyone should be able to see this, as I have seen it, if they climb Monboso, a range of the Alps …" The subtle effect of shadows falling on faces was also derived from his own observations of nature: "Look around the streets when evening comes, and look at the faces of men and women as well when the weather is bad: how gentle and full of grace they are." In fact, sunshine and cloudless skies are never seen in Leonardo's paintings. To achieve the effect of *sfumato*, Leonardo worked with the finest, thin oil glazes, which he then applied sensitively over a dark priming coat. He perfected the art of carefully blending colors so that not even the slightest brushstroke is visible. Conservators have discovered that he even used his fingers and the ball of his hand for this purpose. Leonardo's *sfumato* was a revolutionary innovation in art and had an immeasurable effect on the development of painting up until Rembrandt's *chiaroscuro*. Previously painters had separated objects clearly through color and tone so that they appeared distinct both from each other and the background, almost as if they had been "cut out". Especially in Florentine art, line was considered a more important pictorial element than color. *Sfumato* gave the impression of all the objects in a picture being connected; the near and the far form a single uninterrupted continuum in space and a slight fuzziness allows objects to appear intangible and almost unreal. The French cultural philosopher André Malraux formulated it in the following way: "Leonardo, who did away with contours and boundaries by placing objects in a blue distant twilight, … created a space such as had never been seen in Europe before; this unbounded space drew the pictorial figure and the viewer into it, in order to flow away into infinity."

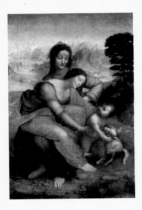

Virgin and Child and St. Anne, 1506–1513
Complete picture and details
Oil on wood
168 x 130 cm
Paris, Musée du Louvre

Last Years

At the age of 61 Leonardo was obliged to move yet again – after the French had been expelled from Milan there were no further opportunities for work. He traveled to Rome via Florence. At that time the Eternal City was experiencing an unparalleled artistic boom. The Renaissance popes were investing enormous sums in art and architecture. Rome became the leading artistic metropolis, a city in which Michelangelo and Raphael set the tone. Leonardo himself now seldom took up his brush; contemporaries were surprised and somewhat bemused to observe his scientific experiments. Finally, he set off on the longest journey of his life at the invitation of the king of France.

At the court of François I in Amboise he spent the last years of his life, admired and respected by those around him. Free of external obligations, he only occasionally drew a costume design or an architectural sketch.

Cortéz attacks the Aztecs

Portrait of Leonardo da Vinci as an old man

1513 The Spanish sailor Vasco Nuñez discovers the Pacific Ocean, which he names the South Sea.

1514 Copernicus speaks for the first time about his theory that the Earth revolves around the sun.

1515 Switzerland declares permanent neutrality.

1517 Luther announces his 95 theses in Wittenberg and lays the foundations for the Reformation.

1519 Charles V is named Emperor and announces: "The sun will never set on my Empire." Hernàn Cortéz invades Mexico and begins the conquest of the Aztec Empire.

1513 On September 24, accompanied by Melzi, Salai, Il Fanfoia, and Lorenzo, Leonardo leaves Milan and reaches Rome in December. He takes rooms in the Belvedere Palace of the Vatican.

1516 Death of his benefactor Giuliano de'Medici. Leonardo leaves Rome.

1517 Arrival in France at the invitation of the French king François I. Leonardo lives with his friend Melzi in the small chateau of Cloux near Amboise. Cardinal Luigi d'Aragona visits him and reports that the artist's right hand is lame.

1519 Leonardo writes his will. He dies in Amboise on May 2 at the age of 67 and is buried there in the monastery church of St. Florentin.

Opposite:
Self-portrait, ca. 1513
(possible forgery from the 19th century)
Drawing
33.2 x 21.2 cm
Turin, Bibiloteca Reale

Right:
St. George and the Dragon, 1515
Drawing
Windsor, Royal Library

In Papal Rome

In December 1513 Leonardo arrived in Rome. He had several unfinished paintings with him, as well as his collected notebooks, which now numbered well over a hundred. Giuliano de'Medici, the brother of the pope, had rooms set up for him in the Belvedere Palace of the Vatican, and paid him a monthly allowance. Leonardo seems not to have played a prominent role in the Eternal City; the elderly man remained a loner at the papal court amidst all the younger painters and sculptors. Rome at that time was a magnet for artists from throughout Europe. In the Middle Ages, the ruins of ancient Rome had been treated as a series of quarries, in which cattle grazed.

After the popes returned from their exile in Avignon in 1417, the city slowly began to awaken from its slumbers. The patronage of the popes was a contributory factor in this, though their spendthrift policies were attacked by the German reformer Martin Luther. The men occupying St. Peter's throne during this period were not in fact renowned for their humility and piety; it was rather as power politicians and art lovers that they left their mark upon the age. Julius II, who laid the foundation stone for the new St. Peter's and brought artists such as Michelangelo, Raphael, and Bramante to Rome, died in 1512.

His successor, Leo X, also liked to style himself a patron of the arts, but Leonardo does not seem to have

Sketch of a church façade, ca. 1515
Drawing
21.3 x 15.2 cm
Venice, Galleria dell'Accademia

Leonardo da Vinci chose the Classical forms of Renaissance architecture for the church façade, and organized it by using a rhythmic arrangement of wider and narrower sections. The sketch is similar to designs by Michelangelo for the façade of S. Lorenzo in Florence which he produced for Pope Leo X.

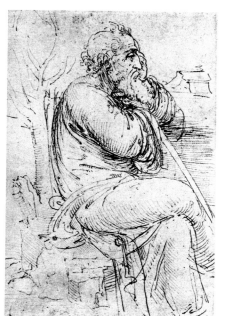

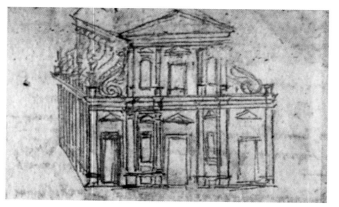

Old Man, ca. 1513 (detail from a sketch book)
Pen and ink drawing (facsimile)
Florence, Gabinetto dei Disegni e delle Stampe

Full of melancholy, this old man supports his chin in his hands and gazes off into the distance. He seems like an ancient philosopher or a biblical patriarch. The mood of the drawing may well reflect Leonardo's own state of mind during his stay in Rome, although the work is not a self-portrait in the real sense of the word.

Dome of St. Peter's in Rome, photo

Raphael
Pope Leo X,
1517–1518, (detail)
Oil on wood
155.2 x 119 cm
Florence, Palazzo Pitti

Pope Leo X was a son of Lorenzo the Magnificent from the Medici family. He was considered an educated, artistic man who was not averse to the pleasures of life. Raphael was one of his favorite artists. The portrait, one of Raphael's last works in his own hand, shows the pope as a connoisseur of the arts: he holds in his hand a magnifying glass with which to examine a manuscript decorated with miniatures.

profited from this. Vasari recorded the mocking comments the pope was said to have made when he learned that the first task Leonardo had undertaken for a newly commissioned painting was to begin distilling the final coat of varnish: "Good Heavens! This man will never produce anything – he thinks of the end before the work has even begun." Unfortunately, we know very little about Leonardo's change in circumstances while in Rome. He found it irritating that the pope forbade him to dissect corpses. Leonardo continued his anatomical studies on the bodies of animals, and devoted himself to researching the laws of gravity and the quadrature of the circle. His notes reveal that he was annoyed by unreliable assistants, whom he thought were deceiving him. If Vasari is to believed, he liked to surprise his visitors with strange tricks that caused more shock than amusement. He made inflatable animals out of bladders, which he pumped up with bellows until they filled an entire room; and he had a tame grasshopper fitted out like a dragon with wings and horns, which he carried about in a box. When his benefactor Giuliano de'Medici died in 1516, Leonardo saw no reason to stay in Rome. He followed the call of François I, who had ascended to the French throne the previous year, and left for France.

The High Renaissance in Rome

Florence may be the home of Early Renaissance art, but the major works of the High Renaissance are to be found in Rome. Within a short space of time – around 20 years – enormous cycles of paintings, sculptures, and buildings were created, which seemed to contemporaries to represent the very pinnacle of art. But one cannot speak of a single, unified High Renaissance style; the artistic personalities who characterized the age were too diverse.

While Leonardo generally operated in Florence and Milan, Michelangelo and Raphael created their most famous work in Rome. There were two reasons why Rome became the center of the High Renaissance: the city was home to the works of the Classical Age, which provided a constant source of inspiration; but above all it was the popes – Julius II and Leo X – with their great commissions who created the material conditions for the splendors of the age. When Leonardo came to Rome in 1513, Michelangelo had already completed his monumental *Ceiling Frescoes in the Sistine Chapel*. Raphael had been working since 1508 on painting the Stanza, a series of rooms in the Vatican palace. One of the most important of these murals is the *School of Athens*. Bramante's Tempietto, a round central plan structure in Classical form, was one of the great architectural achievements of the High Renaissance.

But what was peculiar to these works, and what did they have in common? A characteristic feature of High Renaissance art is a striving for complete harmony and balance. Harmony does not here mean rigidity but a lively play of opposites subordinated to a greater whole; this can be seen in the posture of a figure such as Michelangelo's *Delphic Sibyl*. The differing directions of her gaze and her movement are united in a harmonious single whole. As with all of Michelangelo's figures, the youthful sibyl radiates a sense of inner dignity and confidence. Her beauty is not the random beauty of any pretty girl, but an ideal, eternal beauty. The gentle, graceful figures of the Early Renaissance give way to the powerful, self-confident vision of Man in the High Renaissance.

Realism, idealized beauty, and spiritual clarity combine in the art of this era and served as paragons for Western art until the nineteenth century. In the art of the High Renaissance there is no such thing as irrelevant detail, nor is there any place for exaggerated forms or the merely decorative. Every artwork is entirely self-sufficient and forms its own cosmos. The content of this new art is

Michelangelo Buonarroti
The Last Judgment,
1537–1541
(detail: St. Bartholomew)
Fresco
Vatican, Sistine Chapel

Left:
Michelangelo Buonarroti
Ceiling fresco in the Sistine Chapel: Delphic Sibyl, 1509
(detail)
Fresco
Vatican, Sistine Chapel

At the moment I am so taken with Michelangelo that I can take no pleasure in Nature, because I cannot see it with his great eyes.

<div align="right">Johann Wolfgang von Goethe</div>

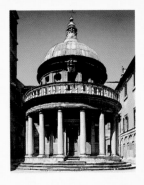

marked by claims to a new spirituality. Artists succeeded in conflating traditional religious themes with a new spiritual depth. Raphael's Stanza paintings encompass the entire intellectual cosmos of the Classical and Christian worlds.

In the so-called *School of Athens* the most famous philosophers of antiquity meet in a sublime architectural setting in order to dispute with restrained, dignified gestures. In the center is the figure of Plato with a white beard, who points to the sky with a typically Leonardo-like gesture. Since the nineteenth century it has been assumed that Raphael intended this figure as a depiction of Leonardo. Michelangelo can be seen in the figure of the dark-haired man in the foreground of the painting thoughtfully leaning on a block of marble. The architect Bramante appears in the figure of Euclid; surrounded by pupils, he is drawing geometrical figures with a pair of compasses. Raphael portrayed himself in the second figure from the right hand side of the picture.

When Raphael died in 1520, the Roman High Renaissance was already nearing its end. In the years

that followed Michelangelo, who was artistically active into his old age, created art that moved ever further away from the Classical harmony of the Renaissance. This art ushered in the transition to the contradictory, exciting epoch of Mannerism, a movement that still has undeserved negative connotations. The internal tensions of Michelangelo, who was constantly pressured by his clients to take on new projects, are expressed in an extreme form in the self-portrait he

painted on the flayed skin of St. Bartholomew in his *Last Judgment*.

Raphael
The School of Athens,
1509–1511
(detail)
Fresco
Vatican, Stanza della
Segnatura

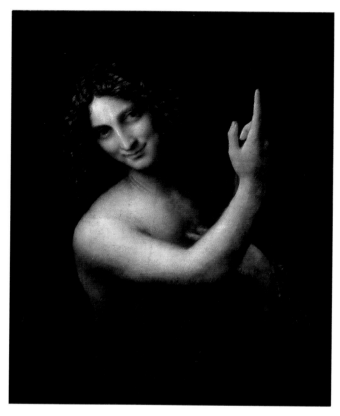

The Last Painting

John the Baptist,
1513–1516
Oil on wood
69 x 57 cm
Paris, Musée du
Louvre

X-ray pictures have
been used to examine
this painting, proving
that it is an original
work by Leonardo.

John the Baptist is the only surviving painting by Leonardo from his time in Rome, and probably the last painting he ever made himself: the older Leonardo became, the less he painted. Increasingly, other interests came to command his attention. But his perfectionism was probably also to blame – his standards were so high that progress on his paintings was painfully slow. His picture of *John the Baptist* shows clearly that this perfectionism could undermine the charm of his work. Many of his artistic achievements are applied here in textbook form: the *sfumato* veiling the girlish features of the Baptist; the seamless *chiaroscuro* modeling of the figure, which allows the body to emerge as a three-dimensional form without using a single line; and the balanced posture of the body with its graceful tilt of the head. The mysterious smile and the gesture of the hands, which were almost a trademark of Leonardo's painting, define the mood of the picture. The painting seems like an exercise in putting Leonardo's theories about painting into practice. In no other painting did he express his conception of light and shade in such an exemplary way. He wrote: "Shade has more power than light, … light can never completely displace shade, at least not that of solid bodies." In another passage he remarked: "Shade is of infinite darkness and there is an infinite number of gradations when moving from darkness to light … Shade is the means of revealing the shape of bodies." It is precisely this effect that the figure of John represents; the figure is modeled by means of deep shadows, which cloak it as if in velvet, and which seem to draw it back into blackness.

Leonardo's extreme form of *chiaroscuro* painting did not escape the notice of Vasari: "… How he seeks after a black, darker than all the others … But his painting finally becomes so dark, that there is scarcely any light there any more … but all

this was done to make the objects stand out in greater relief and to lead art … to perfection."

The painting of *John the Baptist* is difficult to interpret. The crossed staff and cloak of animal skins are part of the traditional iconography and of ancient Christian pictorial conventions. In the Bible, John the Baptist is described as a preacher in the desert where he dresses himself in animal skins and lives on locusts. His pointing gesture is also derived from the Bible: it was John who announced the coming of Christ to the world. But Leonardo's John seems nothing like a Christian ascetic. His smile is suggestive, even mocking. The attractive, half-clothed body of the youthful figures possesses an obviously erotic charge that has caused many scholars to consider it a depiction of Bacchus, the ancient god of wine. It may be that this figure, which combines male and female traits, embodies like no other Leonardo's ideal of beauty. But perhaps the figure of John also reflects something of the bewildering nature of Leonardo, who seemed friendly and composed on the outside but who never betrayed anything of his inner life. When the artist left Rome in 1516 or 1517, he took *John the Baptist* with him to France, and kept it there until his death.

Bacchus, 1510–1515
Oil on wood, transferred to canvas
177 x 115 cm
Paris, Musée du Louvre

Leonardo da Vinci probably intended this picture to be a depiction of John the Baptist in the desert. Later, perhaps while the artist was still alive, the Christian preacher was reinterpreted as a depiction of the ancient god of wine, Bacchus. The wreath of vine leaves, the staff, and the panther skin were not added until the seventeenth century. The contrast between the lightly colored body and the dark rocks is characteristic of Leonardo. Because the picture has been poorly preserved, it is particularly difficult to determine Leonardo's own contribution to the painting.

The Fascination of Water

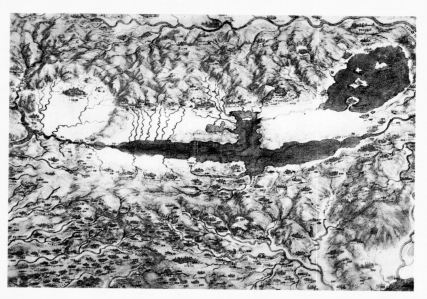

Bird's eye view of the Val di Chiana, 1502
Pen and ink drawing with watercolor (facsimile)
33.8 x 48.8 cm
Florence, Gabinetto dei Disegni e delle Stampe

To Leonardo's mind, water was for the Earth what blood was for the human body. It flowed in an uninterrupted cycle on and through the Earth; it welled up to the surface from springs, filled streams and rivers, formed lakes, and gushed out into oceans. Water evaporated and poured down from the clouds again as rain. Some of his maps, such as the bird's-eye view of the Chiana Valley, seem more like anatomical diagrams. The analogy between the microcosmos of the human body and the macrocosmos of the Earth originated in traditional ideas inherited from antiquity. Leonardo tried to use this conceptual model to unite the natural phenomena he observed into a single coherent image. Water is the predominant motif of Leonardo's work – his art as well as his scientific research. His landscapes all feature water. Waterfalls can be seen tumbling down in his earliest surviving sketch (page 9) and his last work is composed of a series of visions of a deluge with catastrophic torrents. Leonardo's idea of harnessing water and making it useful is reflected in a variety of projects, from constructing canals to draining swamps, which occupied him until the last years of his life. While still in Rome, for example, he drew up plans for draining the Pontine marshes, and in France he developed a scheme for the canalization of waterlogged land near Romorantin. His notes contain ideas for machines for underwater warfare or paddle boats, but there were also practical inventions such as a water meter for measuring the flow through canals. There are many sketches on the subject of hydraulics, and in particular hydrodynamics. In experiments Leonardo researched the effects of flowing water on obstacles, and how eddies and whirlpools form. He captured the invisible power of this element, the direction and movement of its currents, in linear structures in his drawings, comparing them with locks of curly hair. The destructive power of water fascinated Leonardo too; on several occasions he witnessed the disastrous flood waters of the Arno as they broke their banks. The powerlessness of man in the face of Nature must have imprinted itself indelibly on his mind. In his writings he described visions of deluges of biblical proportions: "One sees whole sections of mountains, blasted smooth by violent floods, crashing

Deluge shoes, 1480
(extract from a page of studies)
Metal point, pen, and ink
Codex Atlanticus, Folio 7 r
Milan, Biblioteca Ambrosiana

Water gnaws at the mountains and fills the valleys; if it could, it would transform the Earth into a completely smooth sphere.

Leonardo da Vinci

Vision of a deluge, ca. 1515
Black chalk, brown and
yellow ink (facsimile)
16.2 x 20.3 cm
Florence, Gabinetto dei
Disegni e delle Stampe

down, filling valleys and
causing the waters trapped
behind to rise, whose
torrents then inundate the
broad plains and their
inhabitants." Elsewhere he
wrote: "… and the sea
whipped up by the storm
fights and claws at the winds,
which do battle with its
stormy caps; it shoots up
with its wild waves and
crashes down again and
hurls itself with these waves
against the wind …" His later
sketches of deluges provide
such fantasies with an artistic
form. Drawn in black chalk,
they are amongst his very
last work and form a com-
plete series in themselves.

They are independent pieces
rather than studies for
paintings and were probably
not commissioned. With
terrifying violence the water
in these drawings crushes
everything in its path. But
while mankind is helpless to
prevent its destruction from
these forces, the waves and
vortices of the water itself
unfold in a play of decorative
beauty. For Leonardo water
embodied a fundamental
principle of Nature – that of
constant change and
movement: "And where
today birds fly in great flocks
over the plains of Italy, vast
schools of fish once swam."

Studies of currents,
ca. 1513 (detail from a sketch
book)
Pen and ink drawing
(facsimile)
Florence, Gabinetto dei
Disegni e delle Stampe

On the Trail of Lost Works

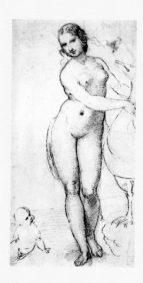

School of Leonardo
(Giampetrino)
Salvator Mundi, 1503–1504
Oil on canvas
Detroit, Institute of Arts

Above:
Raphael
Leda and the swan,
1506–1513
(preparatory drawing)
Pen and ink
30.8 x 19.2 cm
Windsor, Royal Library

No one knows exactly how many paintings Leonardo da Vinci created. Of the many paintings once attributed to him, only 25 are now accepted by more recent scholarship; almost one-third of them are incomplete and the authorship of some is still disputed. From notebooks, drawings, and contemporary copies, and using all the skills of a detective, scholars have managed to track down over a dozen paintings whose original has gone missing. Painted copies were by no means unusual in the sixteenth century. Many art lovers purchased good copies of famous paintings for their collections. For researchers such works lead to enormous problems in tracing their origins; frequently it is virtually impossible to attribute a painting to any one artist. Instead, one speaks of work by the School of Leonardo, by which it is not meant that an artist was literally a pupil of Leonardo but that he painted in his style. It is possible that there was never an original by the master himself for many of his later works, only versions from his designs whose execution he personally supervised. Leonardo's contribution to the *Madonna with the Yarnwinder*, of which there

are several versions and numerous variants, is still being debated. The yarnwinder of the Virgin in the shape of the Cross, which the Christ child looks up at thoughtfully, symbolizes the Passion of Christ. Of Leonardo's lost works, Leda is one of the most important. The picture has survived in several copies, all of which differ in the treatment of the background. In Leonardo's

original it may have been that only the figures of Leda and the swan were completed. Raphael also drew a fine sketch of the group and used the figure of Leda as material from which he developed his own

Below:
School of Leonardo
Leda, 1504–1510
Oil on canvas
112 x 86 cm
Rome, Galleria Borghese

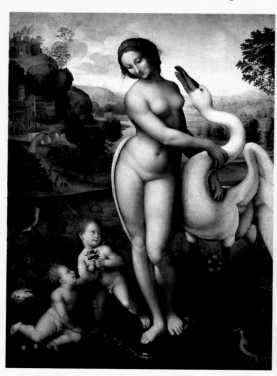

female figures.

The myth of Leda tells of how the father of the gods, Jupiter, seduced this beautiful woman by assuming the shape of a swan. From this union were born Castor (Pollux) and Helen, who are pictured hatching out of their eggs in the painting.

Leonardo created the classic example of a *figura serpentinata* in the figure of Leda: her body describes a gentle, spiral-like movement, her head, arms, and legs all tending in different directions. This motif became an important compositional pattern in the art of the Renaissance, and was later developed to more extreme forms by the Mannerists. Another of Leonardo's lost paintings, of which there are around a dozen copies, was quite different in its conception and effect. It shows Christ bestowing his blessing with a glass ball in his hand symbolizing the world. The frontal view is unusual for Leonardo and can be explained by the traditions associated with this type of figure. The motif of the Salvator Mundi – literally, Savior of the World – goes back to Byzantine icon painting and the so-called vera icon, the "True Face" of Christ, which was supposed to have imprinted itself on the sudarium of St. Veronica. The enormously intense, almost mystical effect Leonardo's picture must have had can still be sensed in some of the copies.

School of Leonardo
Madonna with the Yarnwinder, ca. 1501
Oil on wood
48.3 x 36.9 cm
Thornhill, Collection of the Duke of Buccleuch, Drumlanring Castle

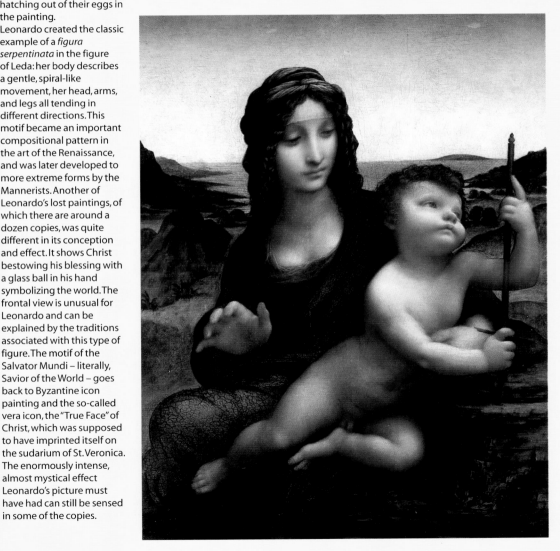

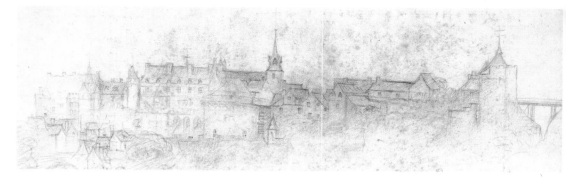

In France

Like his predecessor Louis XII, the young French king François I admired Italian art and brought a number of artists from Italy to his court. He offered the elderly Leonardo da Vinci all the artistic freedom and comfort he could wish for. Leonardo and his friend Francesco Melzi arrived in France in 1517 after a journey of several months, and François arranged for them to live in the small chateau of Cloux close to his castle of Amboise on the banks of the Loire. Even 20 years later the king would still enthuse to the Italian sculptor Benvenuto Cellini about the incomparable genius of Leonardo, with whom he had enjoyed discussions on art and philosophy. Leonardo did not attempt any more large projects while in France. His right hand was lame, and although he was still able to draw with his left he preferred to leave painting to his pupil Melzi. Leonardo's late drawings seem delicate and ethereal, almost like fleeting visions in a dream. Imaginative, elegant costume designs for court masquerades have survived from this time as have depictions of horsemen, which may indicate that he had once again taken up his old dream of an equestrian statue (pages 30 and 72). Leonardo's last architectural project was a chateau in Romorantin, which required extensive plans for canals because of the marshy ground. These plans were, however, never realized.

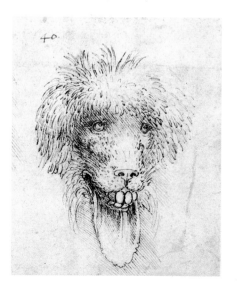

School of Leonardo
Chateau of Amboise,
1517
Red chalk drawing
18.4 x 12.7 cm
Windsor, Royal Library

This drawing is probably by Leonardo's friend, Melzi. It show the view from the window of his last home, the chateau of Cloux.

Fantasy animal,
after 1513
(detail)
Pen and ink drawing
Windsor, Royal Library

Leonardo had always designed costumes, masquerades, and decorations for the theater: at the court of Ludovico Sforza; later in French-occupied Milan; for Giuliano de'Medici; and finally in France. His late works are amongst the most beautiful and imaginative of these drawings.

Drawing of a nymph, 1516
Drawing in brownish chalk
21 x 13.5 cm
Windsor, Royal Library

This figure possesses the grace of Early Renaissance art and the mystique of many of Leonardo's creations.

man because he had not done in art what it was his duty to do. This effort brought on an even stronger attack which was the harbinger of death; the king then went to his side and held his head to show him favor and give him succor so that his pain might be relieved."

Vasari's account of Leonardo's death in the arms of François I sounds too legendary to be true, especially as the king was probably not in Amboise on that day. Leonardo died on May 2, 1518. Melzi wrote to Leonardo's step-brothers: "It is impossible to express the pain that has been caused me by his death …, for every day he showed me the most sincere and heartfelt love. Everyone has been struck by grief because of the loss of such a man, the like of whom it is not in the power of nature to bring forth again." Leonardo was buried in the cathedral of Saint Florentin in Amboise as he had requested in his will. Unfortunately the location of his grave is no longer known; legends and riddles have grown up around the death of Leonardo just as they did around the man and his work while he was alive.

Three of the greatest paintings of this Renaissance genius were still in his possession at the very end: the *Mona Lisa*, the *Virgin and Child and St. Anne*, and *John the Baptist*. Today they can be seen in the Louvre, which is home to the largest collection of Leonardo's paintings in the world.

Historians believe that Leonardo's plans, of which only hastily made sketches remain, influenced other Loire chateaux such as Chambord and Blois.

Early in 1518 Leonardo fell gravely ill. "The king, who visited him often and with affection, came … to him. Leonardo sat up respectfully in bed and described his woes and all their attendant circumstances saying that he had failed God and

Drawing of a young man, ca. 1516
Drawing
20 x 14 cm
Windsor, Royal Library

Leonardo, who sometimes made fun of the excesses of fashion, illustrates a fantasy costume with full, open sleeves in this drawing.

Francesco Melzi
Flora, 1517–1520
Oil on wood
73 x 63 cm
St. Petersburg, The Hermitage

Flora, the goddess of flowers and plants, dreamily contemplates the blossoms she holds in her hand. The marked influence of Leonardo on his pupil and friend, Melzi, can clearly be seen in the face of this gently smiling figure.

Glossary

Al fresco (It. *fresco*, "fresh") Fresco painting, mural painting on wet plaster, as opposed to *fresco secco*.

Allegory (Gr. *allegoria*; from *allegorein* "illustrate differently") Simile, illustration of an abstract concept or content by means of a symbolic depiction, mostly as a personification (i.e. in the form of a person) or a situation.

Altarpiece (Lat. *altare*, "sacrificial table"), also altar-panel A picture often used in the Middle Ages to decorate altars. At first the work of a goldsmith or a sculpture, paintings later became the dominant form. This type of decoration can either consist of a single image or several panels. Often positioned prominently over the altar or as a retable at the back of the altar.

Anatomy (Gr. *anatemnein* "to cut open, dissect") In medicine, knowledge of the structure of the human organism gained by dissection. In the fine arts, anatomical depictions are derived from a precise study of nature and nude models as well as an attempt to reach a profound understanding of the individual bodily functions that determine the external appearance of humans. Renaissance artists developed an interest in the anatomically exact proportions of individual parts of the body, and in the depiction of the life-like movement of the muscles.

Antiquity (Lat. *antiquus*, "old") The Greek and Roman Classical age began ca. 2000 B.C. and ended in the fifth century A.D.. The art, literature, and philosophy of the antique era had a great influence on the Renaissance and later epochs.

Bust (Fr. *buste*, "half-length portrait") Generally a sculpture resting on pedestal that is limited to a depiction of the upper torso, shoulders, and head of a person.

Cinquecento (It. "five hundred") Italian term for the sixteenth century.

Color perspective Means of portraying perspective using the various effects of cold and warm colors to create a sensation of space and depth in a painting. Blue is used to emphasize the depth of the background of a painting and red and yellow for the foreground.

Composition (Lat. *compositio*, "putting together") Formal construction developed according to certain principles, e.g. the relationship of form and color, symmetry/asymmetry, movement, rhythm, etc..

Concetto (It. "idea, concept") Design for the content of a painting.

Condottiere (It. "leader") Leader of an army or band of mercenaries in fourteenth- and fifteenth-century Italy.

Contour Outline of a shape created by a line or contrast.

Contrast Painting differentiates between "light and dark contrast", "color contrast", "warm-cold contrast", "complementary contrast" or "simultaneous contrast".

Drawing Design for a painting or sculpture, but may also be a work of art in its own right; a drawing is considered the direct expression of an artistic idea in a graphic medium.

Facsimile (Lat. *fac simile*, "make (it) the same") A copy – for example of a document, handwriting or a drawing – done as close as possible to the original and generally made using a printing technique.

Gouache Painting technique using water-soluble paint which, in contrast to watercolor, dries to produce an opaque surface. The admixture of binding agents and zinc white produces a pastel effect and a brittle surface.

Landscape painting Depiction of a pure landscape. While landscape was at first simply the means for shaping the background of a painting, at the end of the sixteenth century it developed into an independent genre. In the seventeenth century there were the so-called "ideal landscapes" (e.g. Claude Lorrain's transfigured landscapes) and "heroic landscapes" (e.g. Nicolas Poussin's landscapes whose meaning was emphasized by use of symbols). Landscape painting reached its peak during the Netherlands Baroque. Landscape was revolutionized by the rise of *plein air* painting in the nineteenth century.

Linear perspective see perspective.

Mannerism (Fr. *manière*, "manner"; Lat. *manuarius*, "of the hands") Epoch in art history between the Renaissance and the Baroque, from approximately 1520/30 to 1620. Mannerism did away with the harmonious and idealized forms, proportions, and compositions of the Renaissance. Painting was characterized by more dynamic pictorial scenery; an attenuation of the human body and its portrayal in anatomically contradictory positions; a greater complexity of composition; a counter-intuitive and theatrical use of light, and a more liberal use of color.

Motif The main idea or theme of a work of art.

Nude Depiction of the naked human body.

Oeuvre The entire output of an artist.

Oil painting Painting technique in which the ground pigments are bound with oil. Oil colors are elastic, dry slowly, and can be worked into each other. Oil painting first came to prominence in the fifteenth century, since when it has become the dominant painting technique.

Palette Generally an oval or kidney-shaped surface on which paints are mixed. May also mean all the colors used by an artist or color scale.

Perspective (*perspicere*, Lat: "to look through") Method of representing three-dimensional space on a flat surface. There are several ways of achieving such a sense of depth. Among the most elementary are the use of overlapping (one object being placed behind another) and scale (near objects depicted larger than distant ones). In aerial perspective, distant scenes are painted in lighter tones and less intense colors, and with less clarity.

In Western art since the Renaissance, the most important form of perspective has been linear perspective, in which the real or suggested lines of objects converge on a vanishing point (or points) on the horizon. This method was developed into a formal system in Italy during the early years of the fifteenth century, though an empirical sense of linear perspective had developed in Italy and northern Europe during the Middle Ages.

Portrait Painted depiction of a person. Types include self-portraits, individual, dual, and group portraits.

Profile Side view of a figure emphasized by the outline of the face and in which the forehead, nose, and chin are especially strongly modeled to set them off from the background.

Proportion (Lat: *proportio*, "symmetry, harmony") Relationship of individual elements to each other and to the whole in a painting, sculpture or building.

Renaissance (It. *rinascimento*; Fr. "rebirth") Important art historical era that began in Italy around 1420. The term "rinascita" (rebirth) was coined in 1550 by Giorgio Vasari (1511–1574), who intended it only to mean the superseding of medieval art. By reassessing the models of classical art, Humanism promoted the concept of Nature, Man, and the World oriented to a material existence. A characteristic feature of the Renaissance was the motif of the "uomo universale," an intellectually and physically gifted individual. The fine arts graduated from being a trade to become one of the liberal arts; the artist achieved a higher social status and a greater sense of self-confidence. The arts and sciences were closely and fruitfully related, as seen for example in the discovery of mathematically precise perspective or the advances in anatomical knowledge.

Sarcophagus (Gk. *sarkophagos*, flesh-eater) Long box of wood or stone into which a corpse was placed. Often richly decorated if the deceased was wealthy or high-ranking.

Sculpture One of the main branches of the fine arts characterized by its use of three dimensions.

Self-portrait The artist's depiction of himself.

Silver point Metal rod of copper, brass or bronze whose end had been coated in silver, and which was used on specially prepared paper. In use from the fourteenth century, its light-grey, subtle and uniform lines became the main means of producing drawings in the course of the fifteenth century.

Subject Theme of a painting, i.e. the basic concept underlying a painting that defines its content.

Tempera (It. *temperare*, "mix") During the Middle Ages and Renaissance, the most common medium for pigments; later superseded by the invention of oils. The binding agents were mixed with water to produce an emulsion that was not water-soluble upon drying.

Terracotta (Lat. *terra* "earth", It. *cotta* "fired") Fired, unglazed clay used in Classical times in architecture and as sculptural building elements; also used for reliefs, small sculptures, and everyday items. In the nineteenth century it was a popular medium for portrait busts (e.g. by Auguste Rodin).

Vanishing lines Guide lines that run towards a vanishing point in a picture structured by central perspective. See also perspective.

Varnish (Fr. *vernis* "lacquer, glaze"; medieval Lat. *veronix*) Final transparent coat applied to paintings or craft objects.

Vasari, Giorgio (1511–1574) Italian architect, painter and art historian. His *Vite* (biographies) of Italian artists from 1555/1568 constitute one of the most important art historical records.

Watercolor Water-soluble paints that dry to become transparent and therefore have an especially light and delicate effect.

Index

Acknowledgments

The publisher would like to
thank all contributing museums,
archives and photographers for
granting the right to reproduce
images, and for their generous
support in the production of
this book.

© Property of the Ambrosian
Library, Milano. All Rights
reserved. Reproduction is
forbidden: 24 t.r./b., 33 r., 37 b.,
50 b., 86 b.

© Archiv für Kunst und
Geschichte, Berlin: 5 b.l., 7 t.r./t.l.,
8 b., 17 t.l. (Photo: Joseph
Martin), 18 b., 24 t.l., 27 t.l., 28 b.,
30 b. (Cameraphoto), 39
t.r./t.l./b., 43 l., 47 r., 51 l., 53
t.r./t.l., 57, 58 t. (Photo: Orsi
Battaglini)/b. (Photo: S.
Domingié), 62 b., 64, 66, 67 t.l.,
69, 70 t./b.r./b.l., 71, 79 t.r./t.l.,
back cover; (Photos: Erich

Lessing) 13 t./b., 17 t.r., 41, 47 t.l.,
48 l., 56 r., 68 t., 73, 81 l., 83 t.

© Archivio Fotografico Electa,
Milano: 4 b.r., 7 b., 12 t., 28 t.,
36 t., 48 r., 49 t., 52

© Archivio Museo Ideale
Leonardo das Vinci, Florence:
S. 61 b.

© Property of The Ashmolean
Museum, Oxford: 29 t.

© Bildarchiv Preußischer
Kulturbesitz, Berlin: 67 b. (Photo:
Jörg P. Anders); 80 r. © Photo
Osvaldo Böhm

© Fernando Botero; Courtesy
Marlborough Gallery, New York:
65 t.

© The Bridgeman Art Library,
London: 2, 11, 14, 23, 32 b., 34 t.,
40 b., 55 t.r., 59 t., 61 t.
(Giraudon/BAL), 74 t./b., 83 b.,
85 (Peter Willi/ BAL)

© By Permission of the Duke of
Buccleuch and Queensberry KT:
89

© Bulloz, Paris: 36 b., 37 t., 51 r.

© Le Clos Lucé demeure de
Léonard de Vinci, Amboise: 34
b., 35 b., 50 t.

© Her Majesty Queen Elizabeth II;
The Royal Collection, Windsor:
17 b., 19 t./b., 27 t.r./b., 30 t., 31 l.,
42 t./b., 43 r., 53 b., 55 b., 59 b., 68
b., 79 b., 88 b.l., 90 t./b., 91 t.r./t.l.

© By Permission of the Ministro
per Beni e le Attività Culturali,
Florence: 72a.

© Kunstmuseum Bern; Gottfried
Keller-Stiftung (Inv. Nr. 0054):
69 t.r.

© 1999 Board of Trustees,
National Gallery of Art,
Washington: 18 t.

© Oronoz, Madrid: 5 t.r., 26, 35
t.r./t.l.

© Philadelphia Museum of Art;
Louise and Walter Arensberg
Collection: 65 b.r.

© Rheinisches Bildarchiv,
Cologne: 22 t.

© RMN, Paris: 21 l. (Photo:
Gérard Blot), 32 t. (Photo:
Michèle Bellot), 65 b.l. (Photo:
Gérard Blot)

© Scala, Florence: cover, 4 t./b.l.,
5 t.l./b.r., 6, 9, 10 t./b., 12 b., 15
t./b., 16, 20, 21 r., 22 b., 25, 29 b.,
31 r., 33 l., 38, 40 t., 44 t./b., 45,
46, 47 b.l., 49 b.r./b.l., 54, 55 t.l.,
56 l., 60, 62 t.r./t.l., 63, 72 b., 75,
76 t./b., 77, 78, 80 l., 81 r., 82 r./l.,
84, 86 t., 87 t./b., 88 b.r., 91 b.

All other illustrations were
obtained from the institutions
named in the captions or from
the archive of the publisher.
The publisher has made every
effort to secure all relevant copy-
rights and other commercial
rights for this book; he may be
contacted at any time to answer
queries on these matters.

Key
r = right l = left
t = top b = bottom

© 1999 Könemann Verlagsgesellschaft mbH
Bonner Strasse 126, D-50968 Cologne

Editor: Peter Delius
Art Director: Peter Feierabend
Series concept: Ludwig Könemann
Cover design: Claudio Martinez
Concept, editing, and layout: Jana Hyner, Juliane Baron
Picture research: Jens Tewes, Florence Baret
Reproductions: Digiprint GmbH, Erfurt

Original title: Leonardo da Vinci

© 2000 for the English edition: Könemann Verlagsgesellschaft mbH

Translation from German: Peter Barton in association with Goodfellow & Egan
Editing: Susan James in association with Goodfellow & Egan
Typesetting: Goodfellow & Egan
Project management: Jackie Dobbyne for Goodfellow & Egan
Publishing Management, Cambridge, UK
Production: Ursula Schümer
Project coordination: Nadja Bremse
Printing and binding: Leo Paper Products Ltd., Hong Kong
Printed in China

ISBN 3-8290-4152-7

10 9 8 7 6 5 4 3